室内乐重奏作品集

萨克斯管现代室内乐作品集

Contemporary Saxophone Chamber Works

张鼎　原嫄　薛驭生　主编

中山大学出版社
·广州·

版权所有 翻印必究

图书在版编目（CIP）数据

萨克斯管现代室内乐作品集／张鼎，原媛，薛驭生主编．—广州：中山大学出版社，2022.4
（室内乐重奏作品集）
ISBN 978-7-306-07445-4

I．①萨…　II．①张…②原…③薛…　III．①萨克管—器乐曲—中国—选集　IV．①J643.12

中国版本图书馆 CIP 数据核字（2022）第 026116 号

SAKESIGUAN XIANDAI SHINEIYUE ZUOPIN JI

出 版 人：	王天琪
策划编辑：	陈　慧　张　蕊
责任编辑：	张　蕊
封面设计：	林绵华
责任校对：	陈晓阳
责任技编：	靳晓虹
出版发行：	中山大学出版社
电　　话：	编辑部 020-84110283，84113349，84111997，84110779，84110776
	发行部 020-84111998，84111981，84111160
地　　址：	广州市新港西路 135 号
邮　　编：	510275　传　真：020-84036565
网　　址：	http://www.zsup.com.cn　E-mail：zdcbs@mail.sysu.edu.cn
印　刷　者：	佛山市浩文彩色印刷有限公司
规　　格：	889mm×1194mm　1/16　5.75 印张　120 千字
版次印次：	2022 年 4 月第 1 版　2022 年 4 月第 1 次印刷
定　　价：	58.00 元

如发现本书因印装质量影响阅读，请与出版社发行部联系调换

本书编委会

主　编：张　鼎　原　嫄　薛驭生

编　委：徐坚强　李彦文　戚子谦

　　　　徐乐陶　郭　玉　雷兆雨

　　　　罗　昆　梁思宇　黄远泉

　　　　郑佳永　戴士超

目 录

总 谱

Into the SOUND（C）演奏说明 ··· 2

Into the SOUND（C）Directions ··· 5

Into the SOUND（C） ··· 9

What do you think? ··· 17

打虎上山 ··· 22

归园田居 ··· 32

快乐的女战士 ··· 41

分 谱

What do you think?（Alto Saxophone） ·· 56

What do you think?（Vibraphone） ··· 58

What do you think?（Marimba） ··· 59

What do you think?（Electronics） ·· 60

打虎上山（Soprano Saxophone） ·· 61

打虎上山（Alto Saxophone） ·· 63

打虎上山（Tenor Saxophone） ·· 66

打虎上山（Baritone Saxophone） ·· 68

归园田居（Soprano Saxophone） ·· 70

归园田居（Alto Saxophone） ·· 72

归园田居（Tenor Saxophone） ·· 74

归园田居（Baritone Saxophone） ·· 76

快乐的女战士（Soprano Saxophone） ··· 78

快乐的女战士（Alto Saxophone） ·· 81

快乐的女战士（Tenor Saxophone） ·· 83

快乐的女战士（Baritone Saxophone） ··· 85

总 谱

Into the SOUND（C）演奏说明

Into the SOUND（C）是一首基于作曲家戚子谦的即兴演奏曲目 Into the SOUND，为萨克斯管演奏家张鼎而写的多媒体作品，其配器为植入扬声器的高音萨克斯管和次中音萨克斯管。

设备

- 电脑（带 Max 8 安装程序）
- 声卡
- 夹式麦克风
- 头戴式麦克风
- 二或四声道扬声系统
- 植入扬声器
- 踏板

演奏者需要安装并通过使用电脑软件 Max 8 运行名为"Into_The_SOUND（C）.maxpat"的程序来操作作品的电子部分。可下载该软件的网站为 https：//cycling74.com。

有关使用说明，请参考 Max 8 程序中的附件。如有任何疑问，请联系作曲家（chihimchik@hotmail.com）。

踏板

演奏者需要使用踏板来提供 Max 8 程序中"空格键"信息（如 Delcom USB 脚踏开关），以在演奏过程中触发电脑程序的事件。通过触发事件，电脑部分会根据作品的展开而做出相应的反应。

植入扬声器

植入扬声器的选择取决于表演者，选择扬声器必须满足以下条件：此作品的目的是利用萨克斯管来控制植入扬声器所产生的声音，为了达到此目的，选用的扬声器应该只向萨克斯管内发声；扬声器的形状应为圆形，并且应与乐器的喇叭口完全吻合。

建议安置扬声器时，把一块布放在扬声器和乐器之间，以免刮损乐器，同时，扬声器也不易掉落或漏出声音。

准备准则

乐谱的作用是给表演者在即兴表演时做参考。

尽管表演者需要遵循作曲家的想法和决定，但也可以自由探索乐器和电子音乐部分的声音。强烈鼓励表演者按自己的方式演绎本作品。

在自由即兴部分中，未指定的音乐元素（包括音量、节奏、声音上的选择等）皆由表演者决定。

作品时长

作品预期的表演时间大约为 15 分钟，不应超过 20 分钟。

萨克斯管声部选择（非必要）

此作品是为高音萨克斯管和次中音萨克斯管创作的，但同时允许演奏者以中音萨克斯管代替次中音萨克斯管。如果表演者决定这样做，应保留次中音萨克斯管部分的原有声效，并将原本次中音萨克斯管的吹奏部分转换为中音萨克斯管的音高和音调，如下所示：

$$(\text{Tenor} \longrightarrow \text{Alto})$$
$$^{\#}C5 \longrightarrow {}^{\#}G4$$
$$^{b}B3 \longrightarrow F4$$
$$\text{altissimo D} \longrightarrow \text{altissimo A}$$

扩音部分（非必要）

本作品所需的麦克风和扬声器仅用于萨克斯管和植入扬声器的扩音功能。如场地对于扩音系统而言太狭小（回音过强），表演者则只需使用植入扬声器，而无须使用任何麦克风和扩音设备进行表演。

四声道扬声系统（非必要）

如果演出场所不能产生足够的回音，表演者也可以选择使用四声道扬声系统。但是，萨克斯管的声音与扬声系统之间的音量应该保持平衡。

夹式麦克风

次中音萨克斯管上的麦克风必须是夹式麦克风（如森海塞尔 E908B）。请将夹式麦克风指向乐器的低音 B 音孔（如图 1 所示），以获得从乐器发出的植入扬声器的声音。

头戴式麦克风

演奏次中音萨克斯管时会通过口型发出吹笛头的声音，请将头戴式麦克风尽可能靠近嘴边放置，以便更好地捕捉音效。

备注

"V" 代表短暂停顿。
"," 代表较长的停顿。
"gliss." 代表滑音。
" * 1" 代表带有长线的音符和方框；这些是即兴演

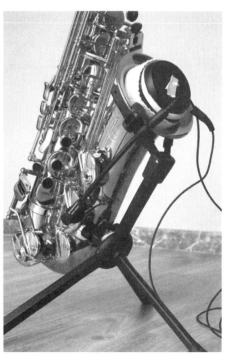

图 1　夹式麦克风

奏的参考材料。演奏者应以方框前的引入音作为基本音高，并使用方框内的材料进行即兴演奏。同时，鼓励演奏者使用额外的材料。有下划线且无方框的音符等于长音。线的长度代表不同部分之间的相对长度。

"＊2"代表重复符号：重复使用上一个方框中的材料。

"＊3"代表菱形音符头：泛音。

"＊4"代表踏板点：按下踏板以实现电脑程式中的下一个事件。顶部的数字表示该程式的事件编号。

"＊5"代表方框中的字母"E"：渐渐渗入植入扬声器的声音。

"＊6"代表锯尺线开放部分，演奏者可以在该部分即兴演奏，并将图表作为音高范围的参考。

"＊7"代表在此部分，表演者可以根据以下内容进行即兴演奏：使用长音与植入扬声器的声音产生共鸣和不和谐音（也可以考虑微分音），并自行决定按下踏板添加更多长音的时机；可以引用先前部分的材料；此部分应演奏至少2分钟。

"＊8"代表空心音符头：根据音符的音高按键，不需要吹奏。

"＊9"代表正方形里的音符头：空心的音符头代表演奏时嘴巴张开，实心的音符头则代表嘴巴合上。这些音符之间的箭头表示从一个动作慢慢过渡到另一个动作（慢慢张开/合上嘴巴）。

"＊10"代表以嘴型、舌头位置及嘴巴的开合为基准，运用其交替及变化来操纵植入扬声器的声音以进行即兴演奏。此部分应持续至少1分钟。

"＊11"代表当嘴巴合上的时候，通过交替使用不同的指法，运用从中产生的不同泛音来进行即兴演奏。此部分的演奏时间应比前一部分（＊10）长。

"＊12"代表使用先前所有提及的演奏技法（指法、嘴型、舌头位置、嘴巴的开合）进行即兴演奏，以操纵来自植入扬声器的声音。演奏者同时也可以考虑加入先前部分的材料。此部分的演奏时间应比前一部分（＊11）长。

"＊13"代表交替使用不同的指法（低 $^{\flat}$B 到高 $^{\sharp}$F），同时保持相同的音高 altissimo D（或 Alto 上的 altissimo A），以创造不同的音色和效果。

Into the SOUND (C) Directions

Into the SOUND (C) for soprano and tenor saxophones, implanted electronics, and optional amplification is a written out version of the improvisation set *Into the SOUND* by Chi Him Chik, and is dedicated to Chinese saxophonist Ding Zhang.

Setup

- Computer (with Max 8 installed)
- Audio interface
- Clip-on microphone
- Headset microphone
- 2/4 Speakers
- Bluetooth speaker for implanted electronics
- MIDI pedal

The electronic part of the piece can be achieved by running the patch file named "Into_The_SOUND (C).maxpat" with computer software Max 8 by Cycling '74. The software can be downloaded from the website: https://cycling74.com.

For directions of setup, please refer to the attachment in the Max patch. Please contact the composer (chihimchik@hotmail.com) if there is any question or concern.

MIDI Pedal

A MIDI pedal that provides a "spacebar" key message (e.g. Delcom USB Foot Switches) is required to trigger events of the computer program during the performance.

Implanted Speaker

The choice of implanted speaker to be used is up to the performer. The composer would suggest: Sony SRS-XB10/ SRS-XB12 for tenor saxophone, or Anker Sound Core Mini for alto saxophone.

Other speakers chosen MUST fulfill the following criteria:

The purpose of implanted electronics in this piece is to use the instrument to manipulate the sounds produced from the speaker. In order to achieve that, the choice for implanted speaker should only produce sounds into the saxophone, without "leaking" sounds to the outside. The shape of the speaker should be round and it should fit well into the bell of the instrument. It is advised to use a piece of cloth to fit between the speaker and the instrument so that the speaker will not scratch the bell, and it will not fall off or leak out sounds.

Preparation Guidelines

This score is a guide/map for improvisation.

Although the performer should follow the composer's ideas, decisions, and intentions, he/she is free to exploring the sounds of the instruments and electronics. As a goal, the performer is strongly encouraged to make the music "his/her own way".

During the open sections, parameters that are not specified, including dynamics, rhythms, timbres, etc., are left to the decision of the performer.

Duration

This piece is written with the intended duration of 15 minutes, while the performance should not be longer than 20 minutes.

Voice of Saxophone (Optional)

The score is written in $^\flat$B for soprano and tenor saxophones, while replacing the tenor saxophone part with an alto saxophone is allowed. If the performer decides to do so, he/she should keep everything, including the notes with hollow note heads, as written, while transposing the original tenor saxophone part's playing notes to the pitch and register of the alto saxophone as follow:

$$(\text{Tenor} \longrightarrow \text{Alto})$$
$$^\sharp C5 \longrightarrow {^\sharp}G4$$
$$^\flat B3 \longrightarrow F4$$
$$\text{altissimo D} \longrightarrow \text{altissimo A}$$

Microphone and Amplification (Optional)

The microphones and speaker system called in this piece serves only the purpose of amplification for the saxophones and implanted electronics. If the venue is too limited or small for amplification system, the performer is allowed to perform with only the saxophones and implanted speaker, without any microphone and external speakers.

Stereo/Quadraphonic Speaker System (Optional)

If the situation allows and the performance venue does not create too much reverberation, the performer can also choose to use a quadraphonic system for the amplification of the piece. Though, the volume between the saxophone acoustic sound and its amplification should be balanced—one should not be too overwhelming than the other.

Microphones

The microphone on the tenor saxophone MUST be a clip-on microphone (e.g. Sennheiser E908B). It should be pointed towards the low B keyhole of the instrument (as shown in Fig. 1) in order to capture

the sounds of the implanted electronics that comes out of the instrument.

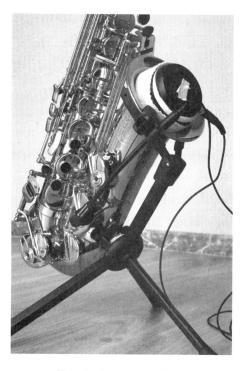

Fig. 1 tenor saxophone

Headset Microphones

The headset microphone should be placed around the mouth so that it captures the sounds that come from the mouthpiece, when the performer opens the mouth while playing the tenor saxophone.

Remarks

V—Short breath.

, —Longer breath/A pause.

gliss. —Smooth glissando.

*1—Note with long lines and bucket of materials: These are suggested materials for improvisation. One should use the note with the line introduced before the bucket as the fundamental note and improvise with the materials inside the bucket. Limited amount of extra material is encouraged. Notes with line WITHOUT a bucket of materials simply means long note. Length of the line is intentional. it represents the relativity of length of improvisation/long tones between groups.

*2—Material repeating symbol: Repeat the same materials from the previous bucket.

*3—Diamond note head: Harmonic from the indicated fingering/note.

*4—Pedal point: Trigger the MIDI pedal to achieve the next event in the computer program. The number indicated at the top refers to the event number of the program, while the text represents what is the program doing at the selected event.

*5—Letter "E" in the box: Fade into the electronic sound.

*6—Curvy line: Open sections, the performer can improvise in this part while using the graph as a suggestion of the range of pitch.

*7—In this section, please improvise with the following instruction: Use long tones to create consonance and dissonance with the drone from the implanted speaker (also consider microtones) and progress as wished by triggering the pedal to add more layers of drones. Quotation of materials from previous sections is allowed. This section should be played for at least 2 minutes.

*8—Hollow note head: Finger the notated note, without playing.

*9—Note head in a square: Mouth open if the note head is hollow, and close if it is solid. Arrow between these notes means slowly transform from one to another (slowly open/close mouth).

*10—Improvise by alternating the embouchure, tongue position, and the shape of the mouth to manipulate the sounds from the implanted electronics. This section should be played for at least 1 minute.

*11—Improvise by alternating different fingerings to produce different harmonics out of the implanted electronics (while the embouchure is closed). This section should be played longer than the previous improvisation section (*10).

*12—Improvise with all mentioned parameters (fingerings, embouchure, tongue position, the shape of the mouth) to manipulate the sounds from the implanted electronics. Playing the instrument and using of quotations from previous sections are also encouraged. This section should be played longer than the previous improvisation section (*11).

*13—Alternate between fingerings, from low $^\flat$B to high $^\sharp$F of the instrument, while playing the same note altissimo D (or altissimo A on Alto) to create different timbres and gestures.

Into the SOUND (C)

选自 *Into the SOUND*

戚子谦（Chi Him Chik）

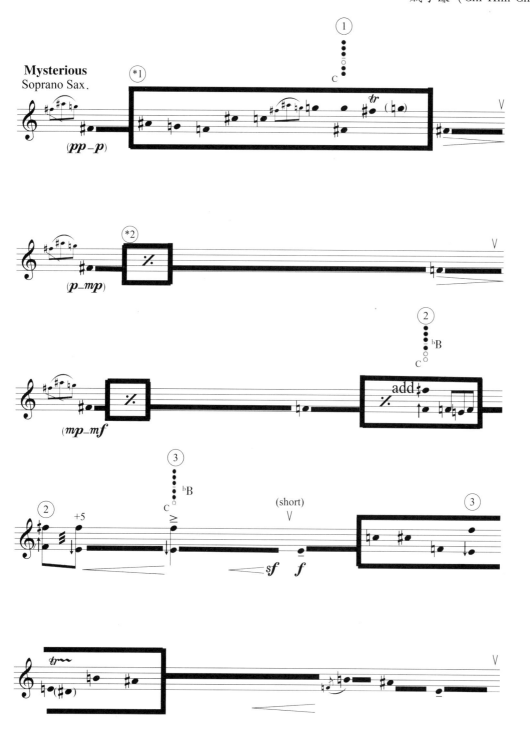

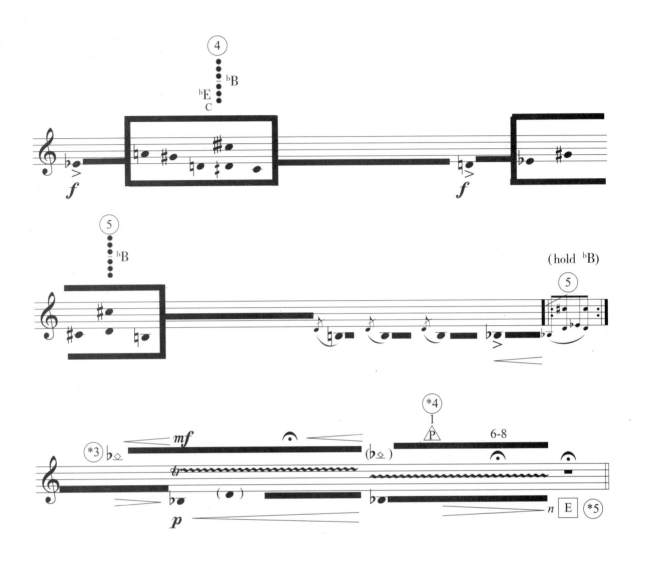

Energetic

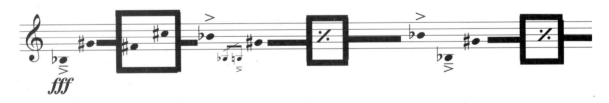

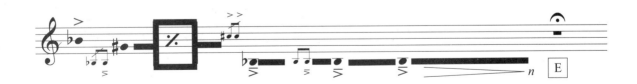

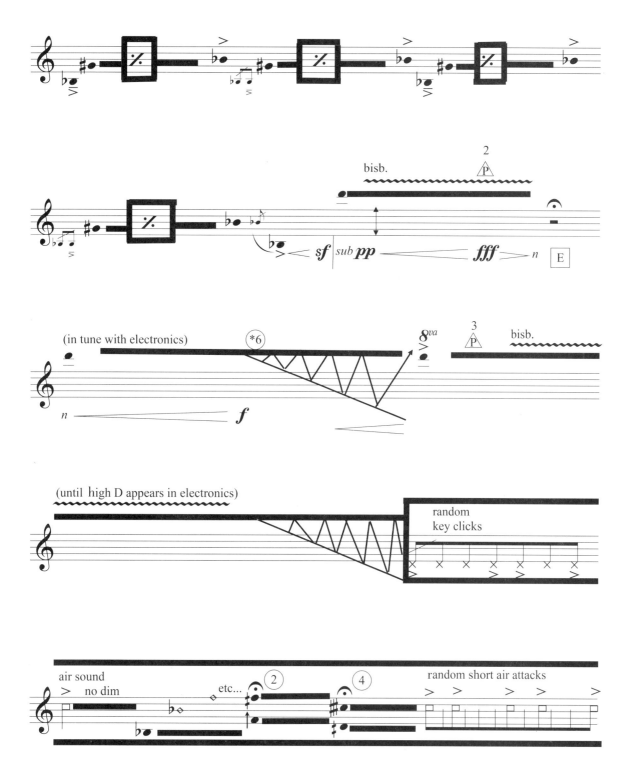

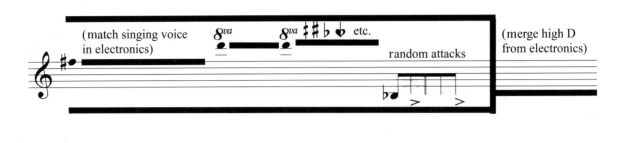
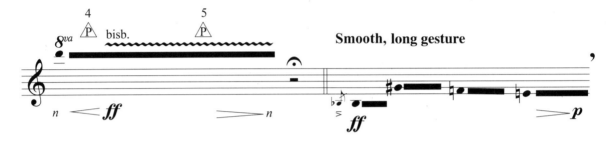
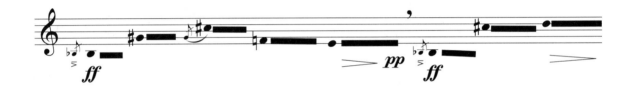
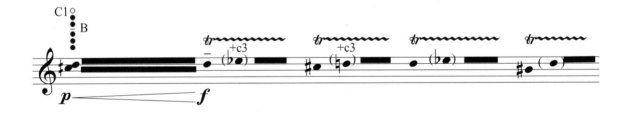
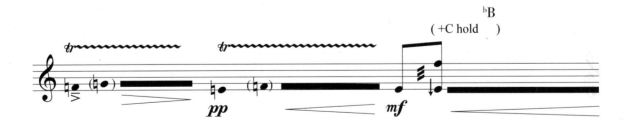

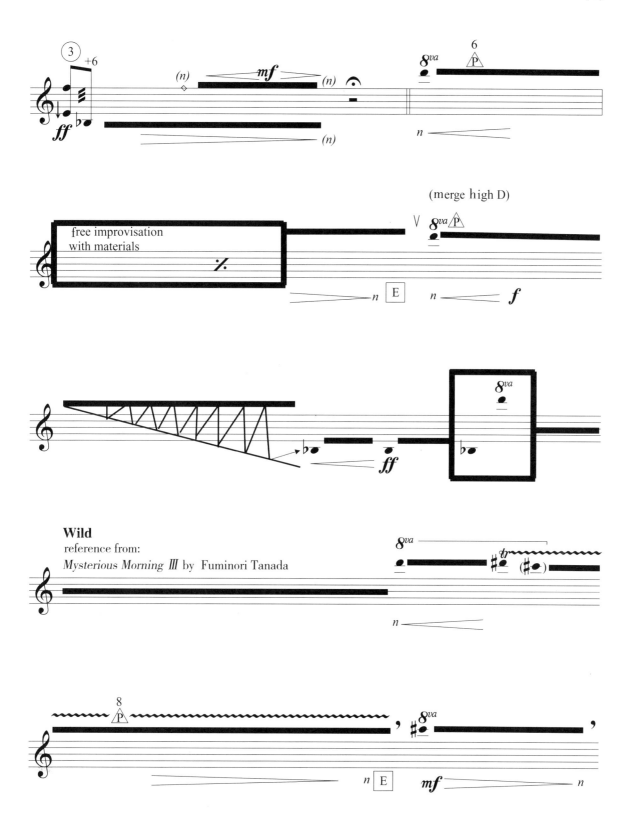

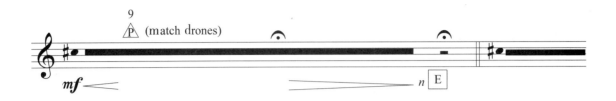
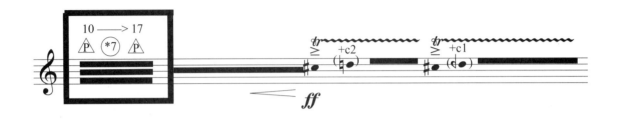
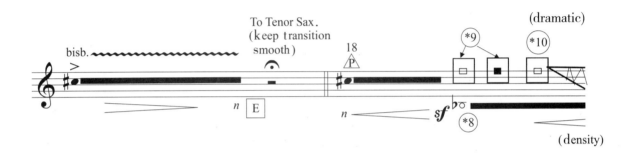
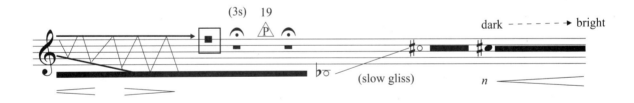

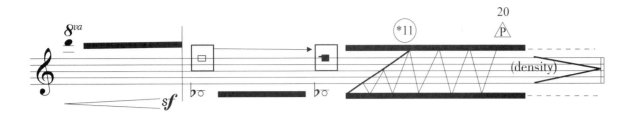
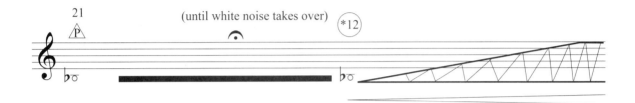
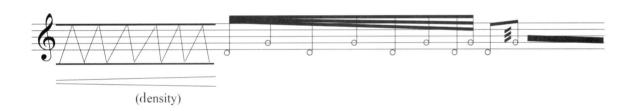
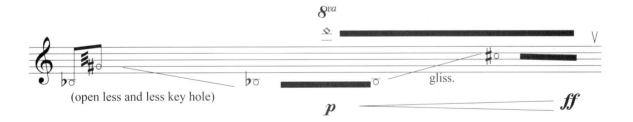
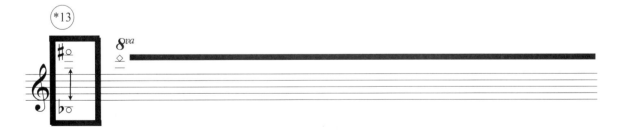

总 谱

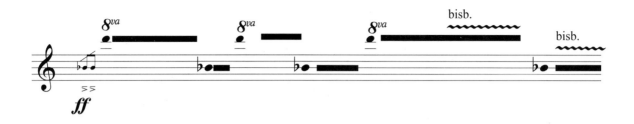

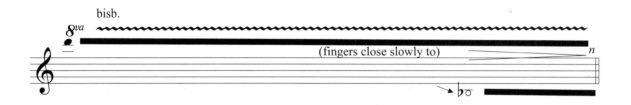

Subtle and unexpected

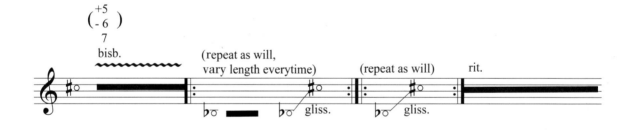

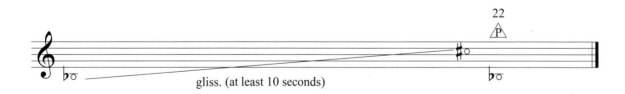

16

What do you think?

Yanwen Li
Stuttgart

First part: Percussionist (Perc.) practices vibraphone alone ca. 30" when he sees Sax. Player (S.), he starts to play score to flirtation S.

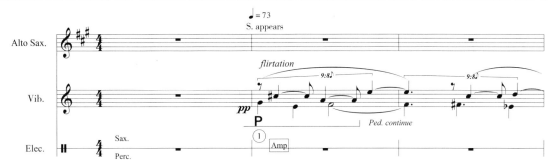

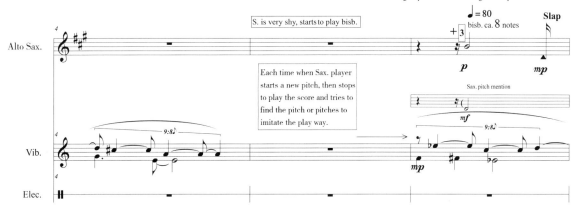

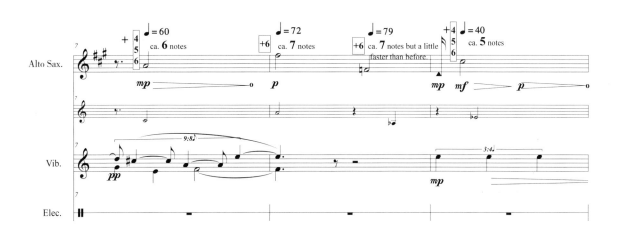

总 谱

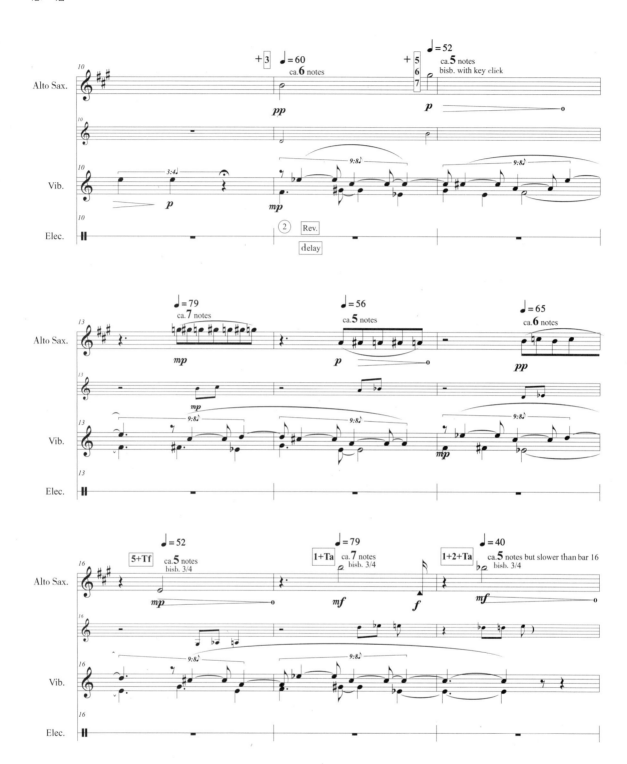

18

What do you think?

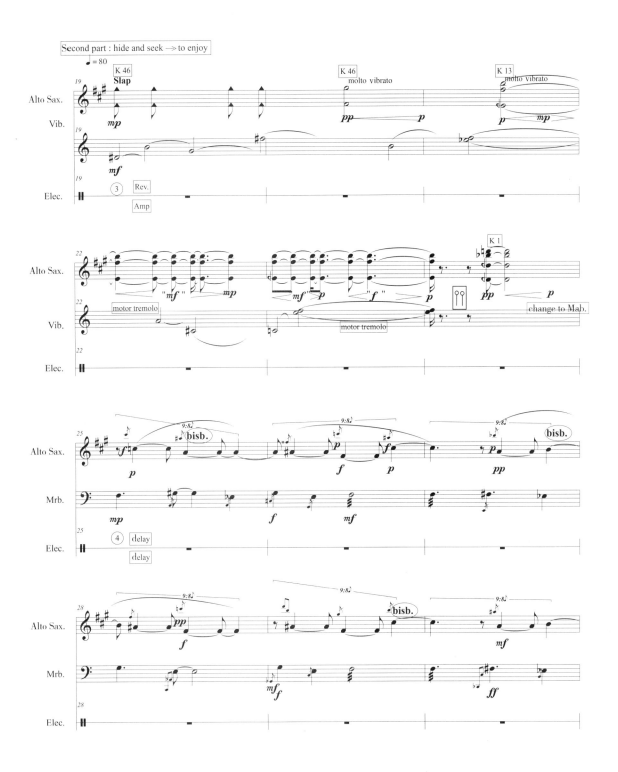

总 谱

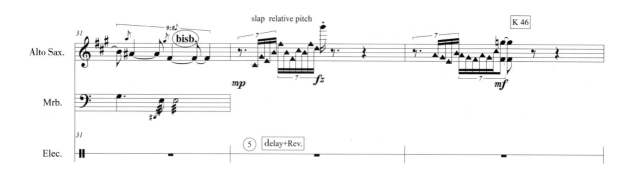
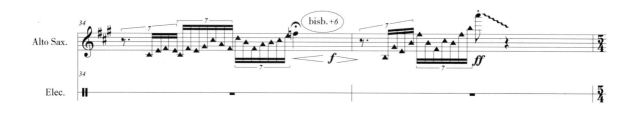
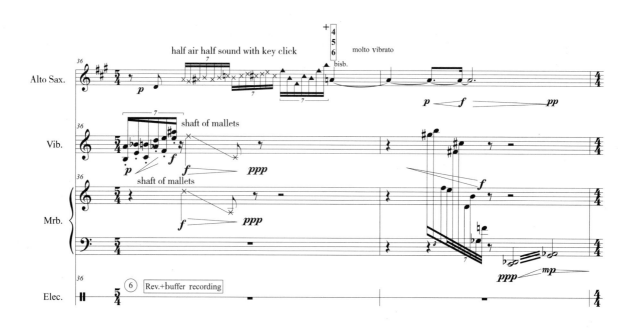

20

What do you think?

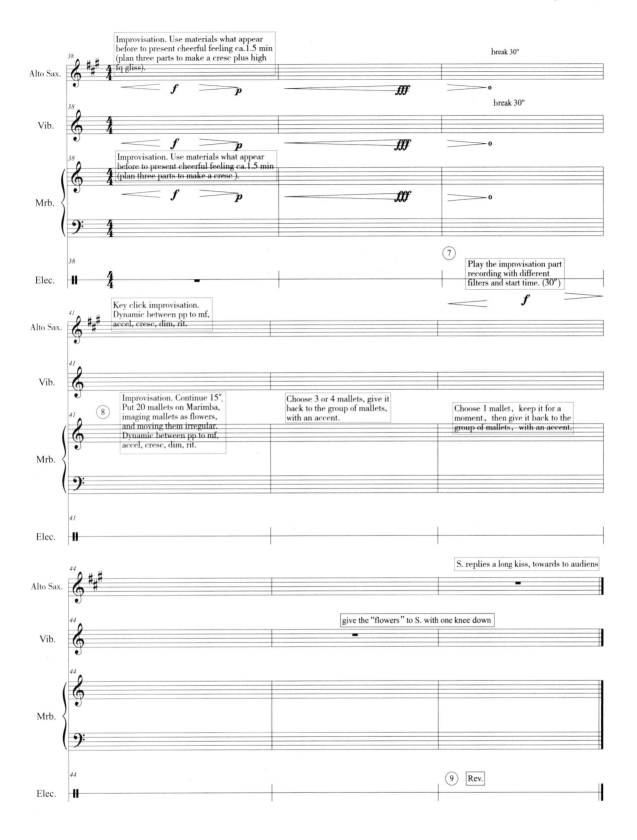

打虎上山

选自现代京剧《智取威虎山》

高一鸣 曲

徐坚强 改编

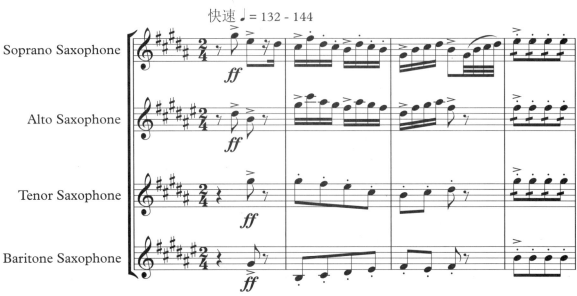

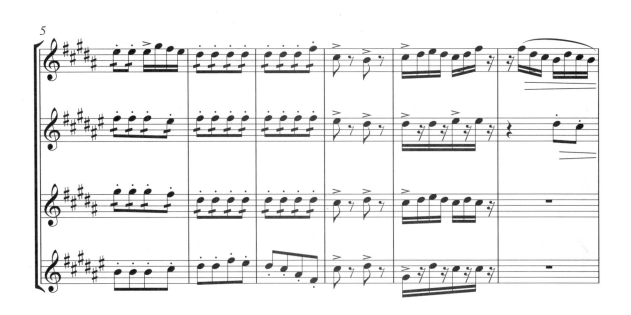

打虎上山

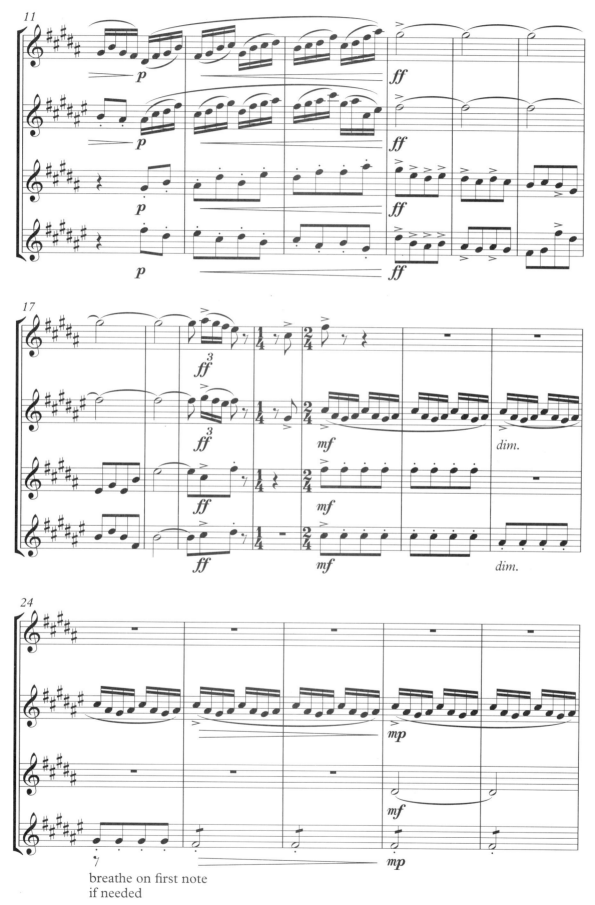

breathe on first note
if needed

总 谱

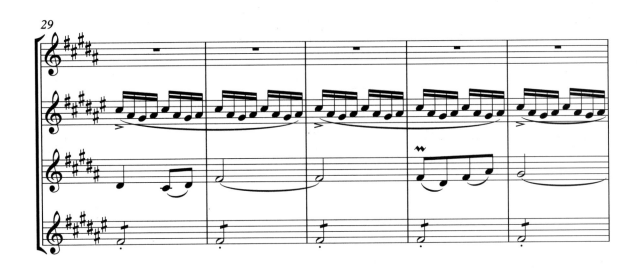
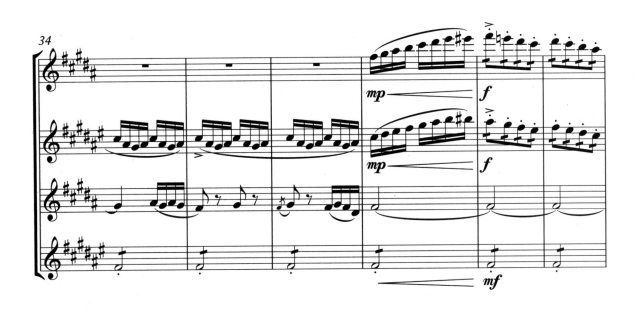
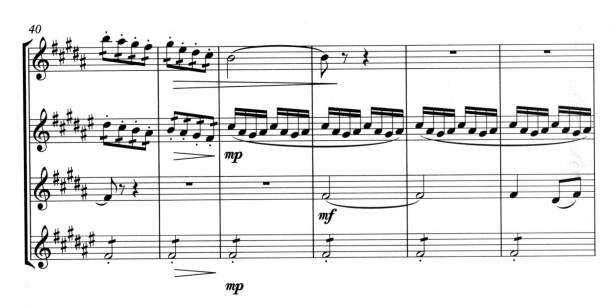

24

打虎上山

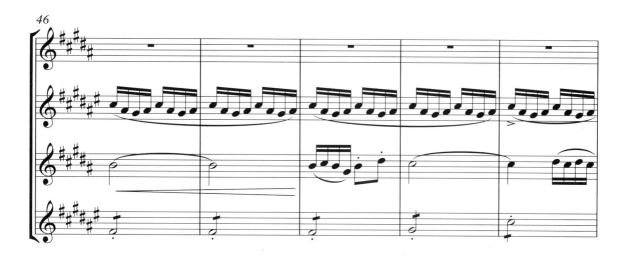
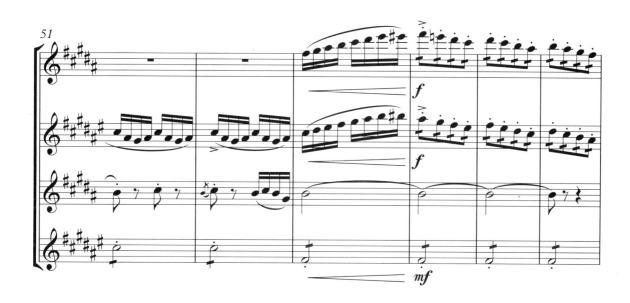
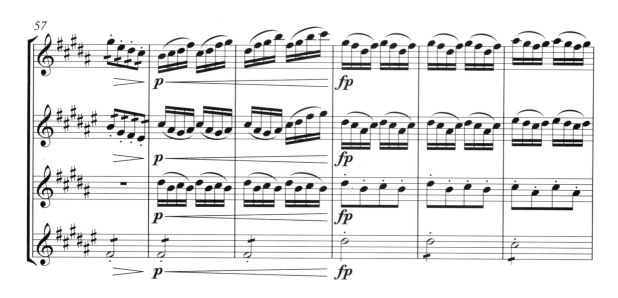

总谱

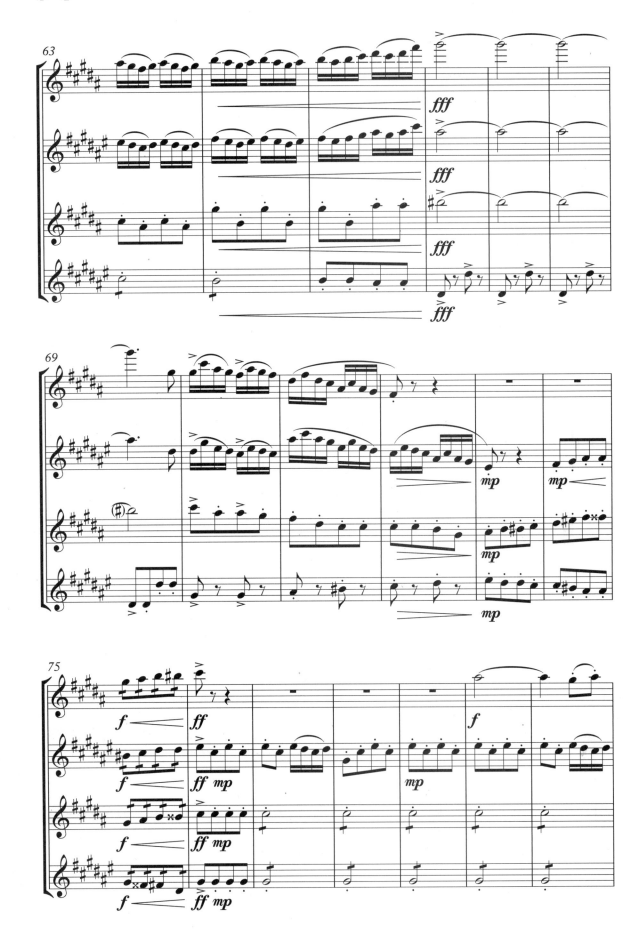

26

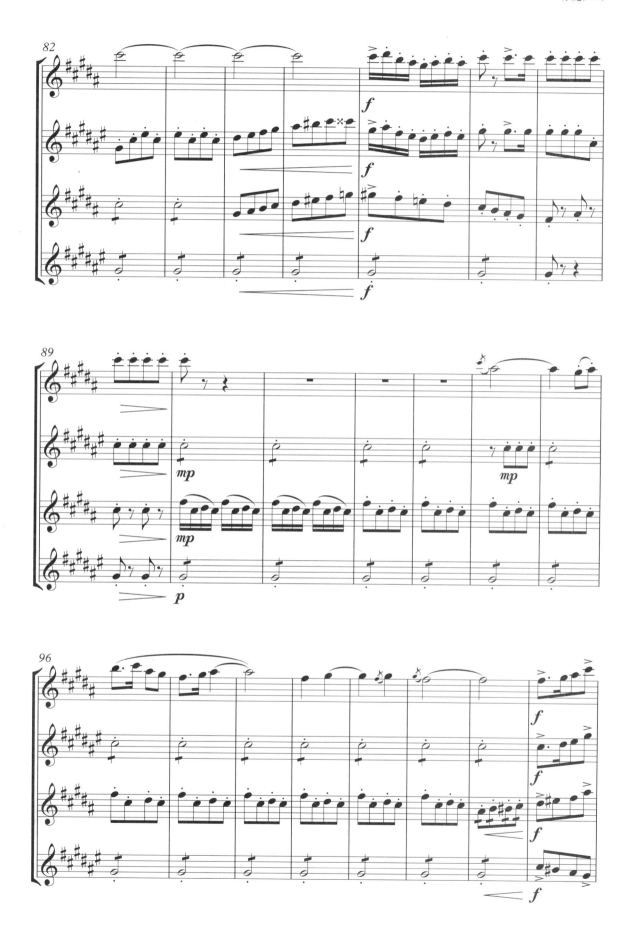

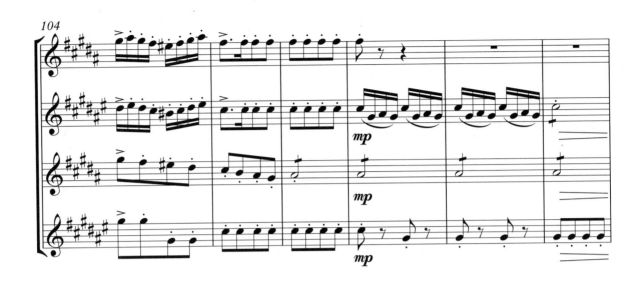
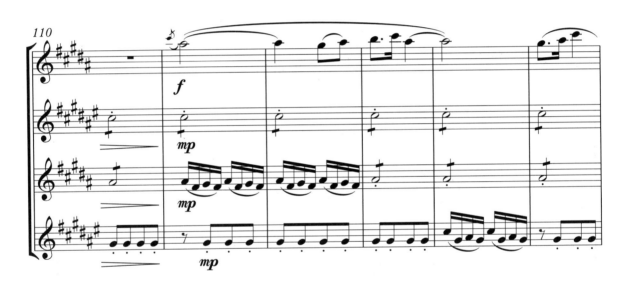
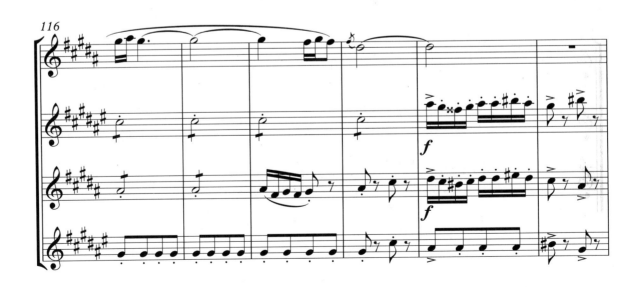

打虎上山

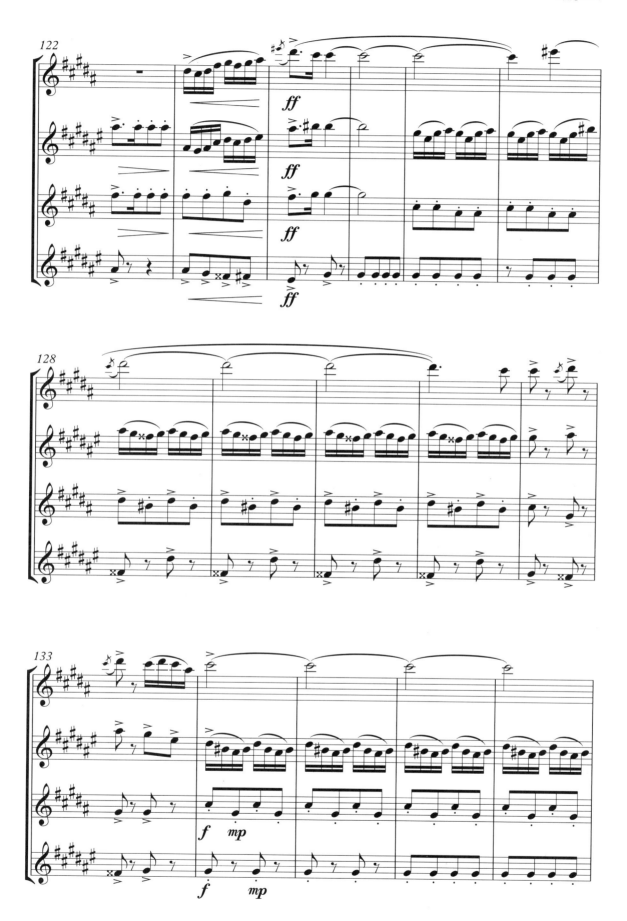

29

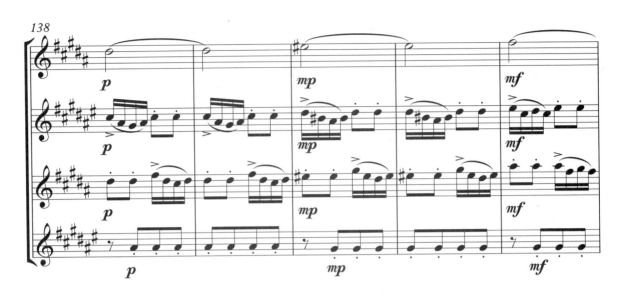
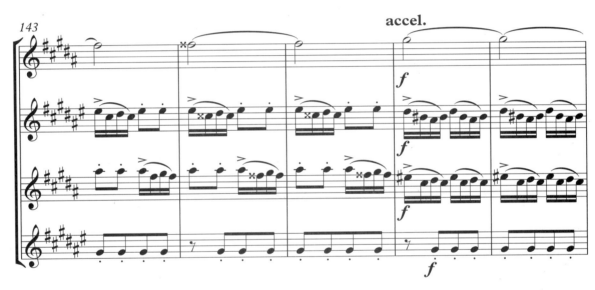
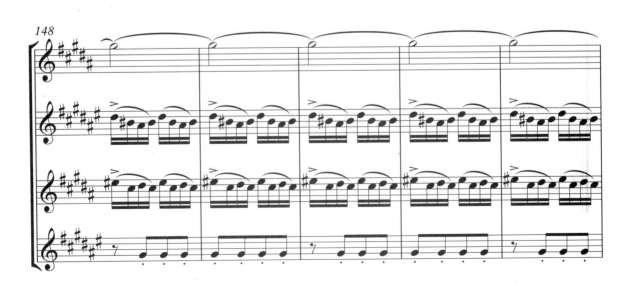

打虎上山

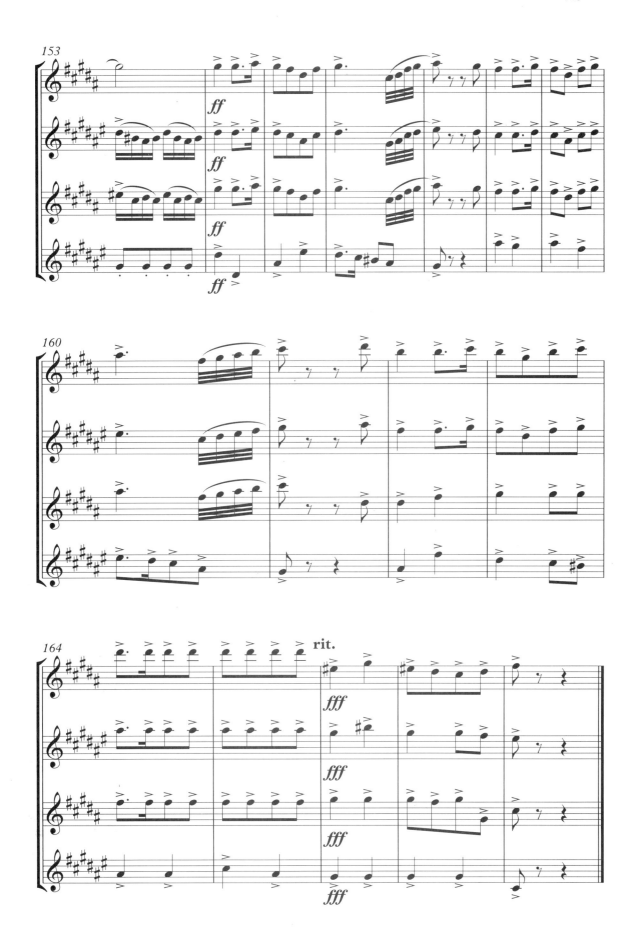

归园田居

陶渊明 诗
徐坚强 曲

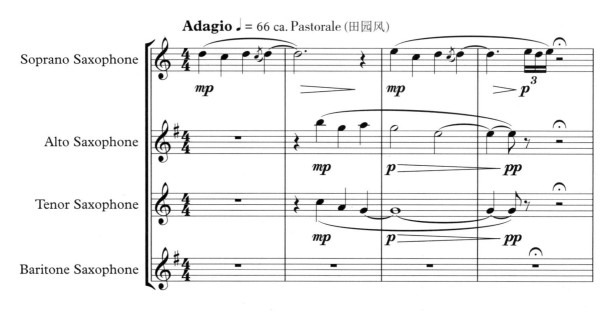

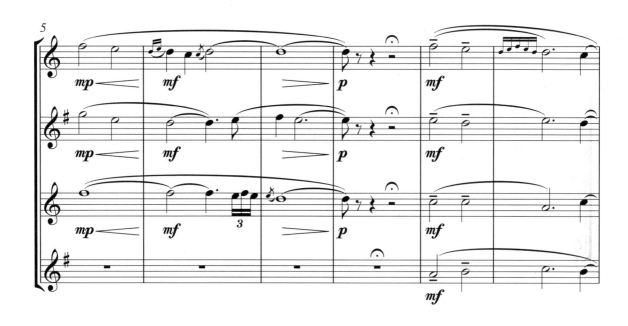

归园田居

Allegro ♩ = 152 ca. Cheerful (愉悦的)

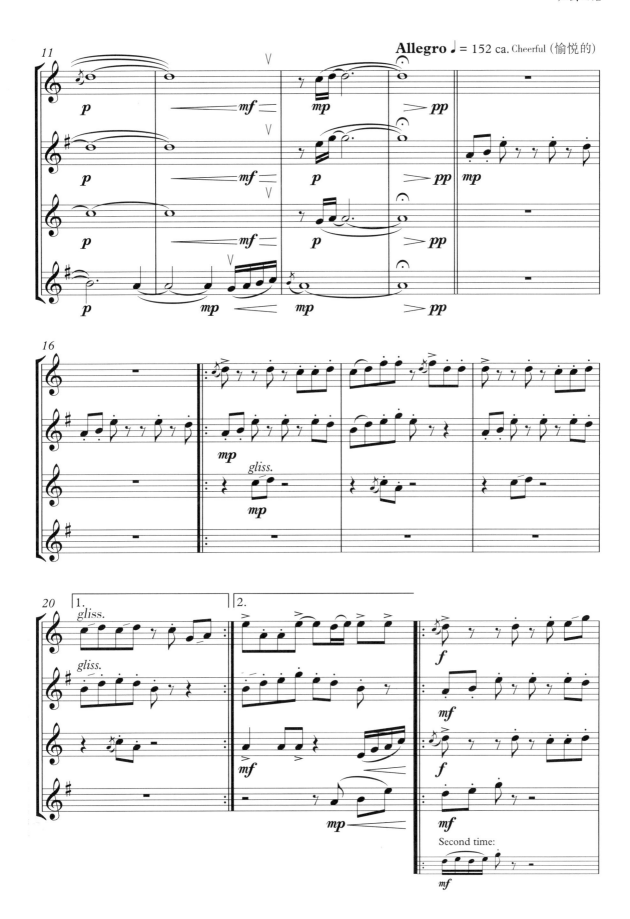

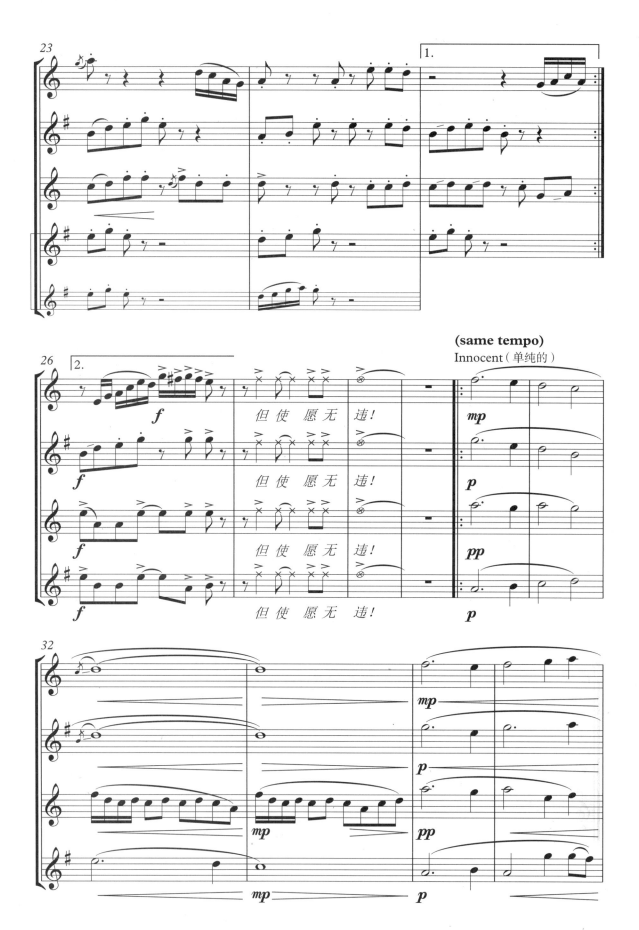

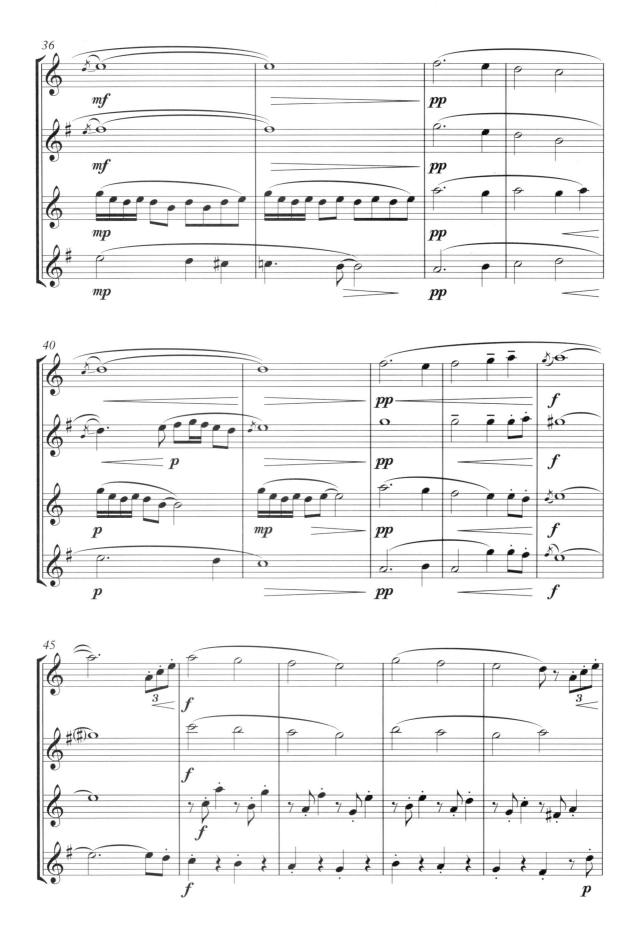

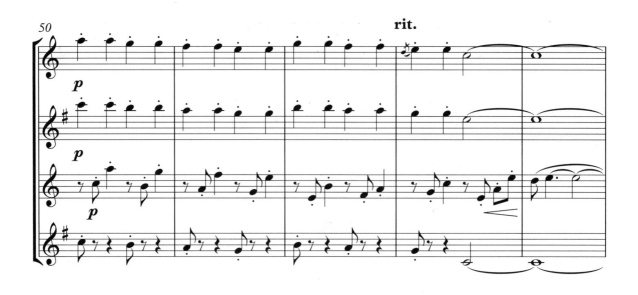
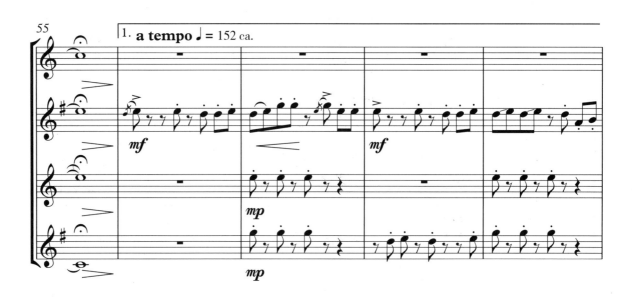
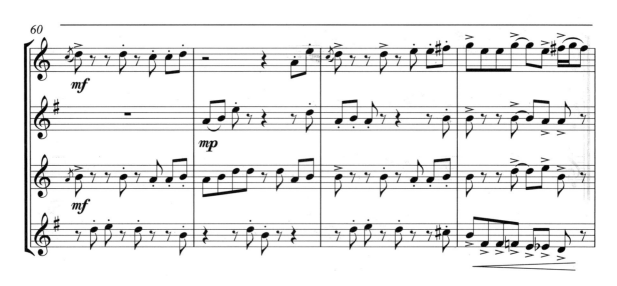

归园田居

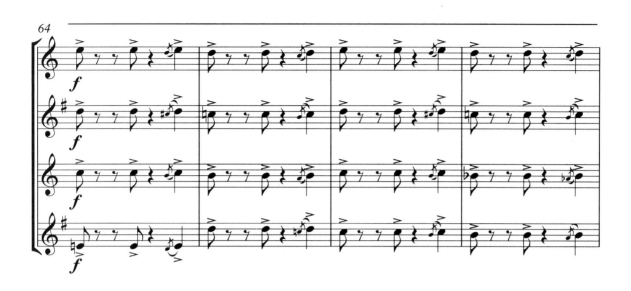
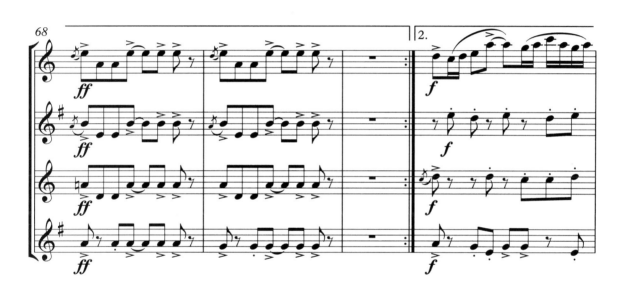

快乐的女战士

选自《红色娘子军》
杜鸣心 吴祖强等 曲
徐坚强 改编

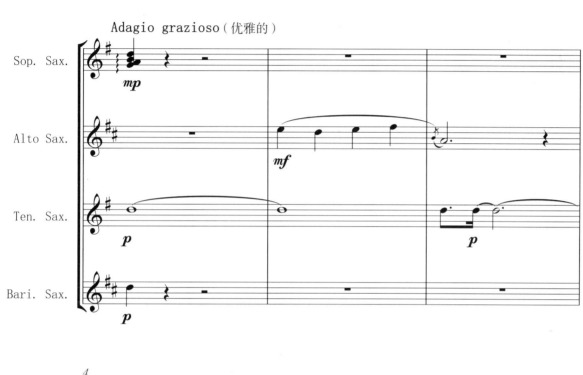

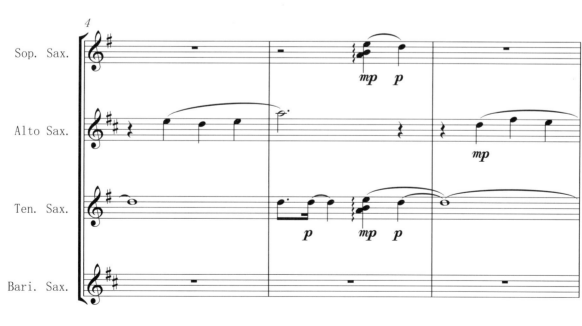

总 谱

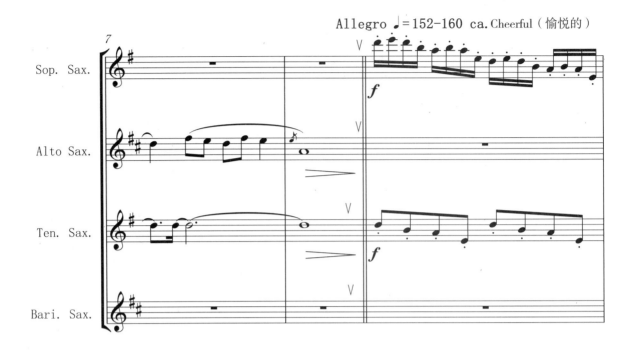

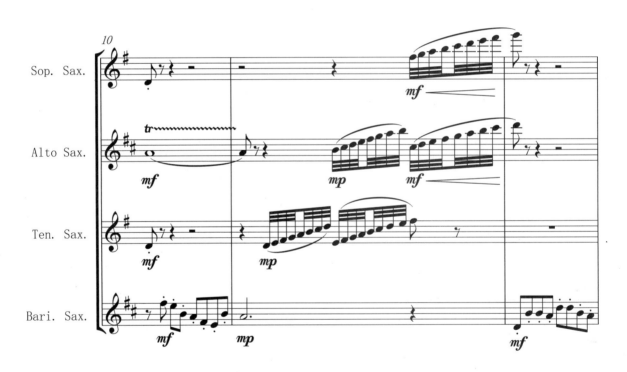

42

快乐的女战士

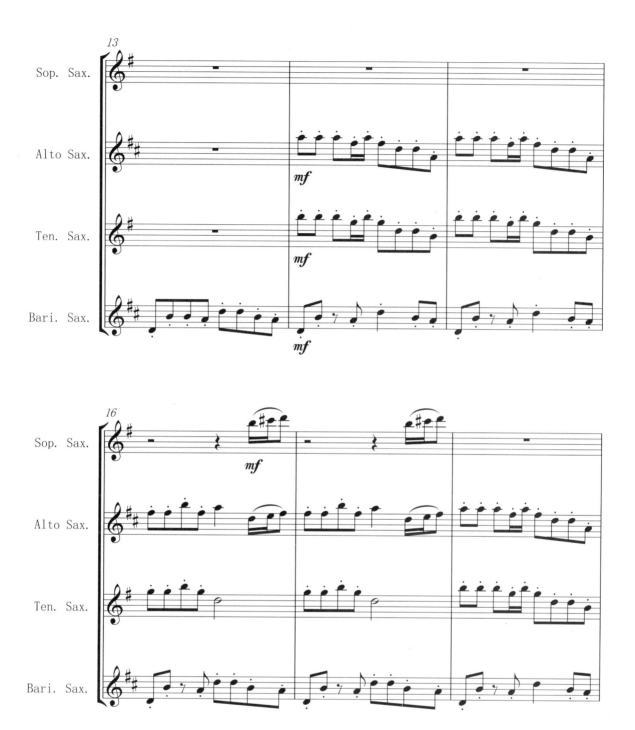

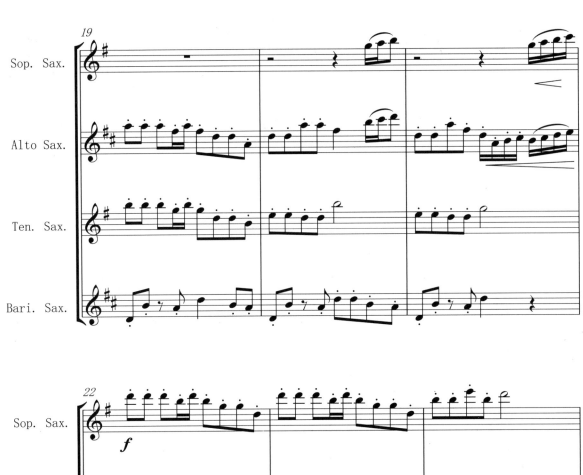

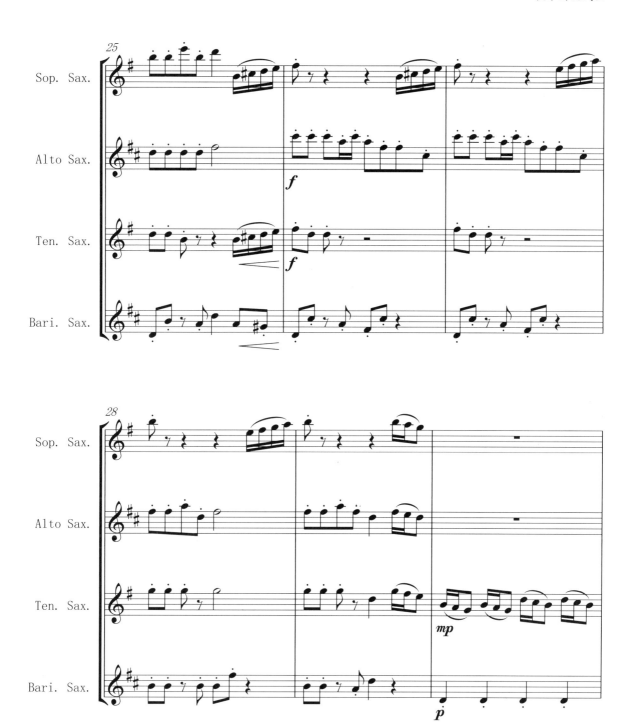

总谱

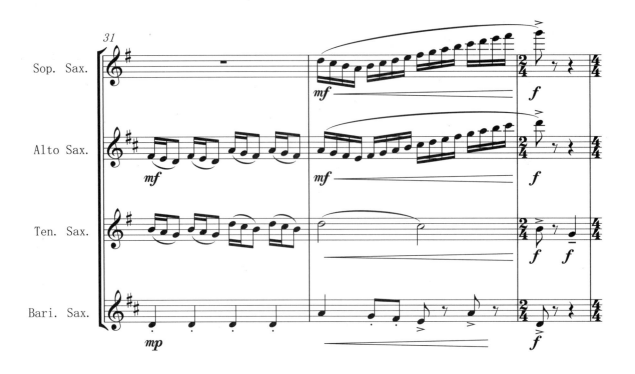

46

快乐的女战士

总谱

48

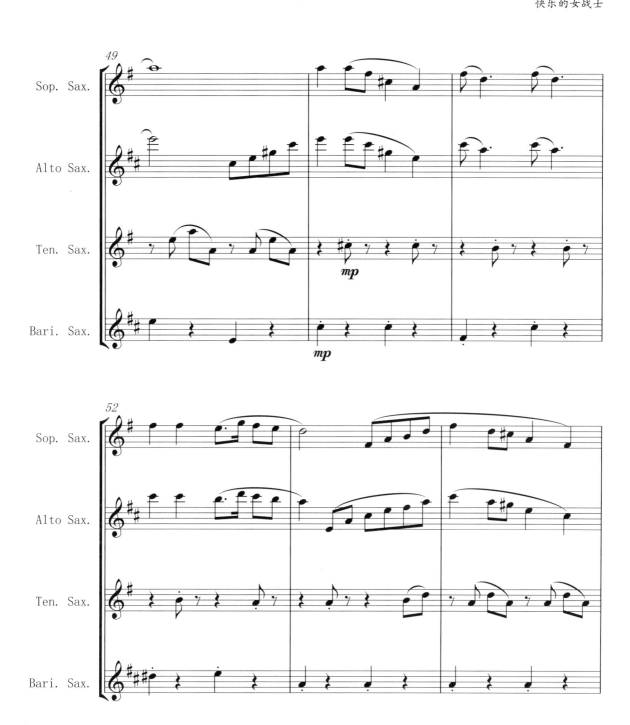

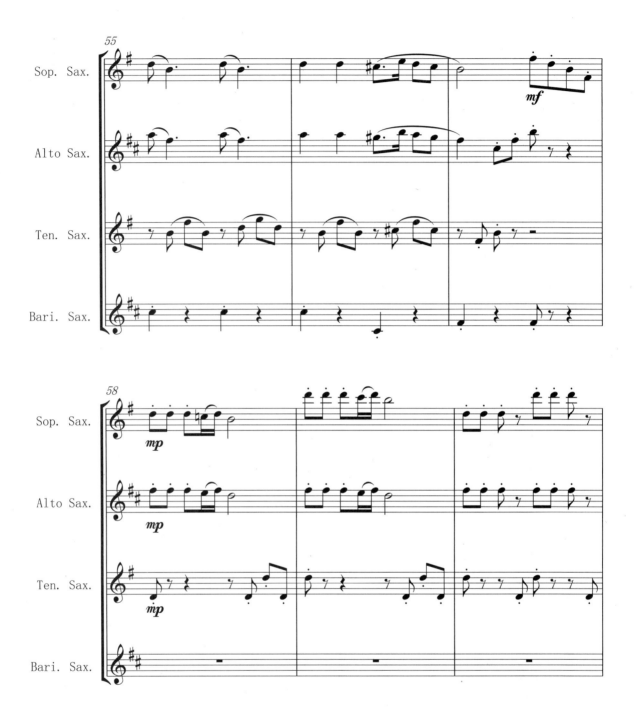

快乐的女战士

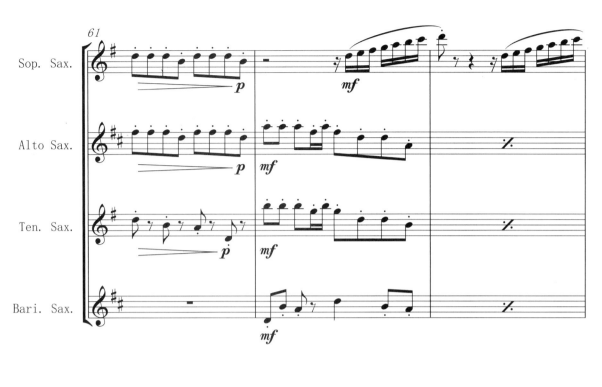

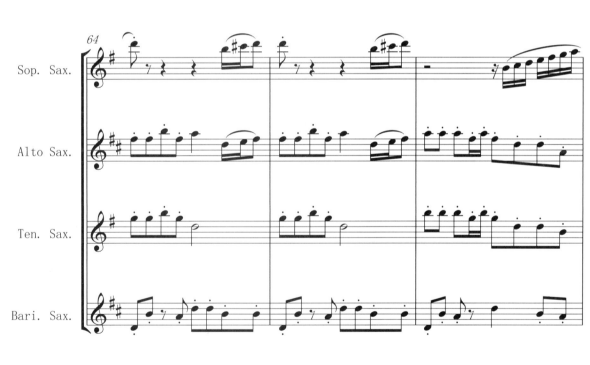

总 谱

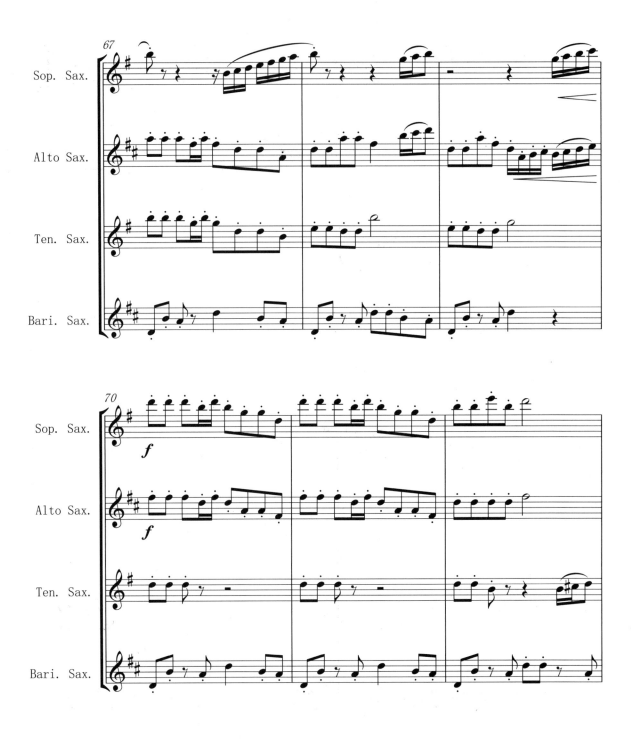

52

快乐的女战士

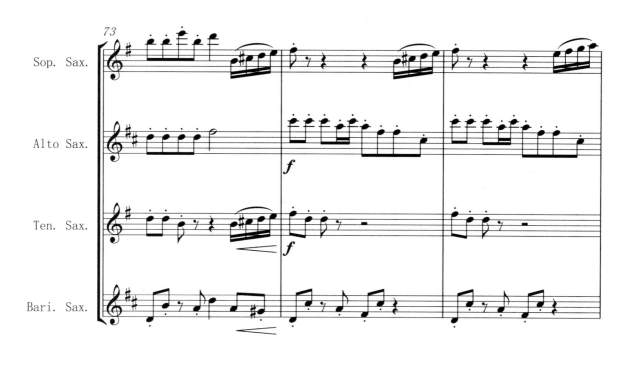

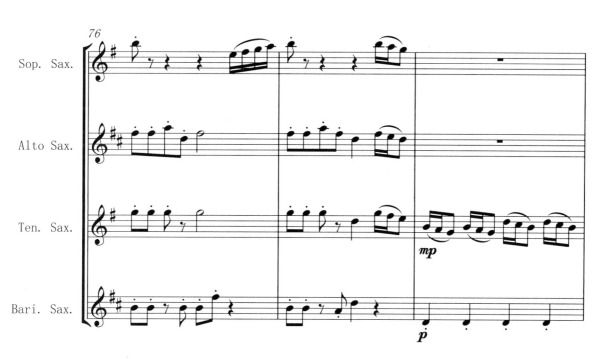

53

总 谱

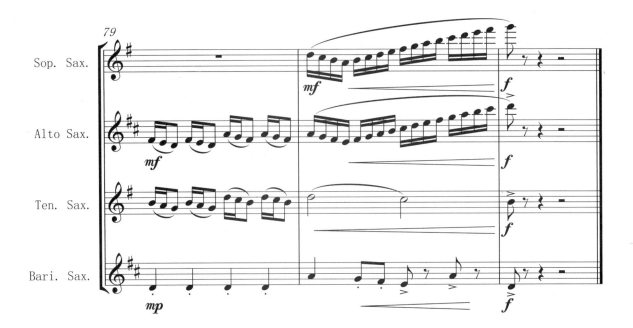

分 谱

What do you think?

(Alto Saxophone)

Yanwen Li

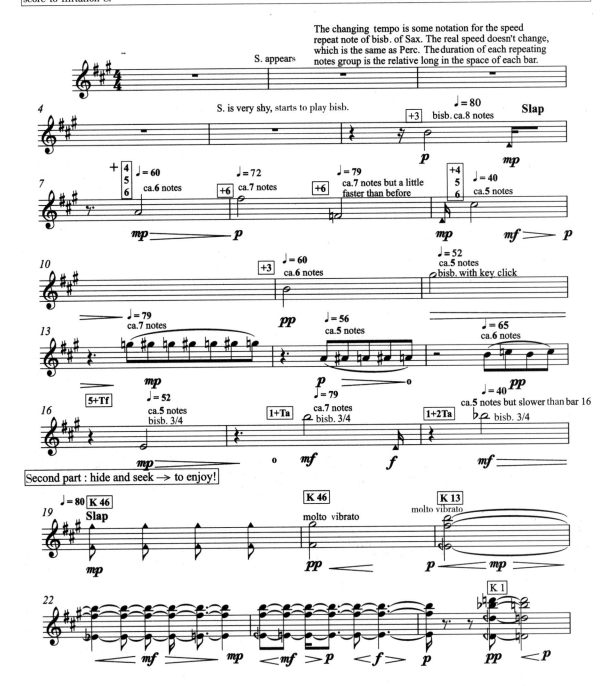

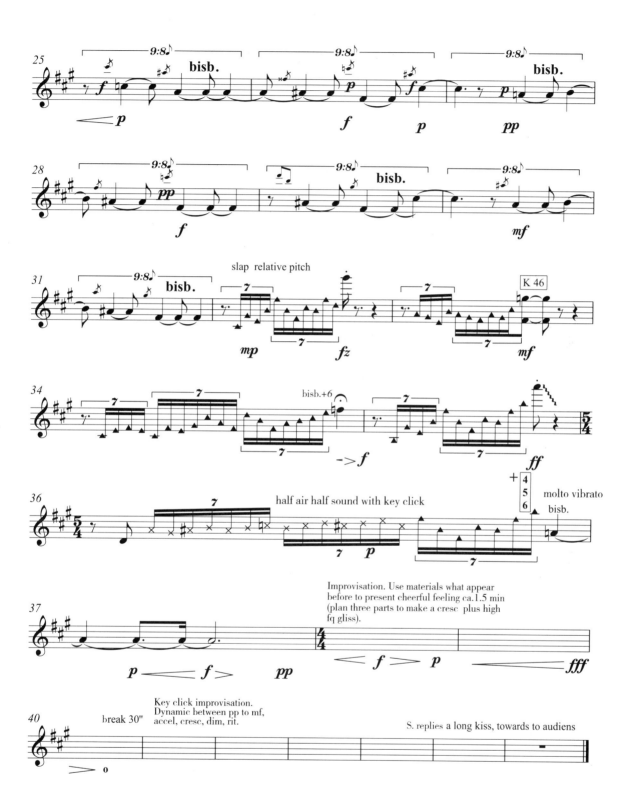

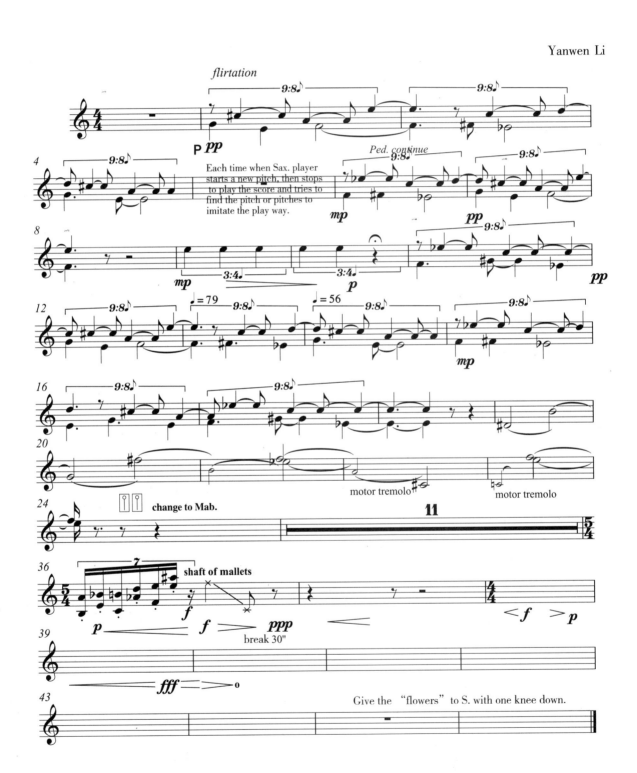

What do you think?
(Marimba)

Yanwen Li

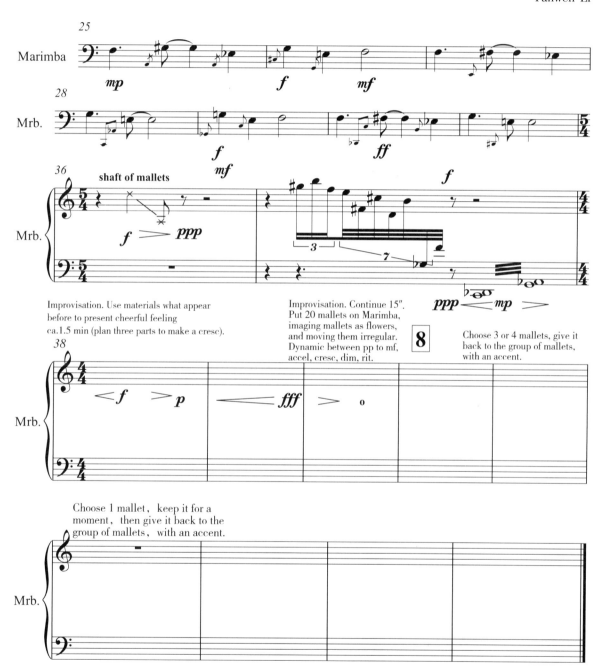

What do you think?

(Electronics)

Yanwen Li

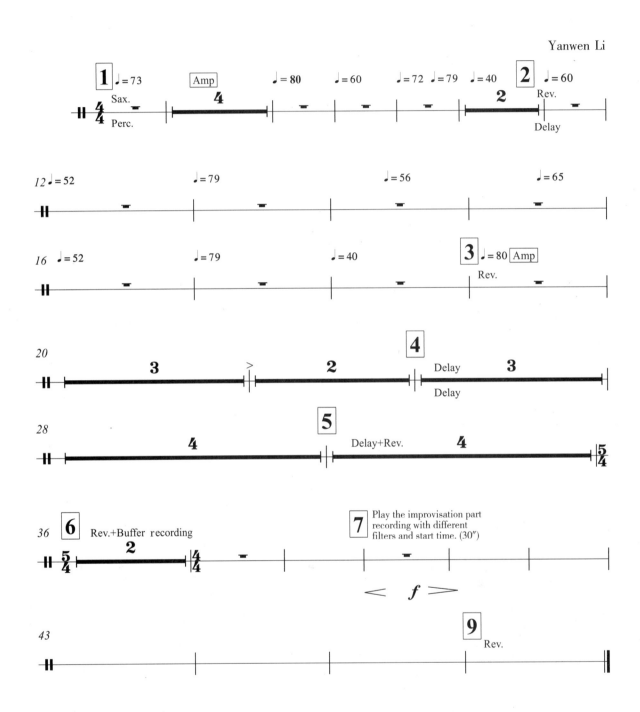

打虎上山

(Soprano Saxophone)

选自现代京剧《智取威虎山》
高一鸣 曲
徐坚强 改编

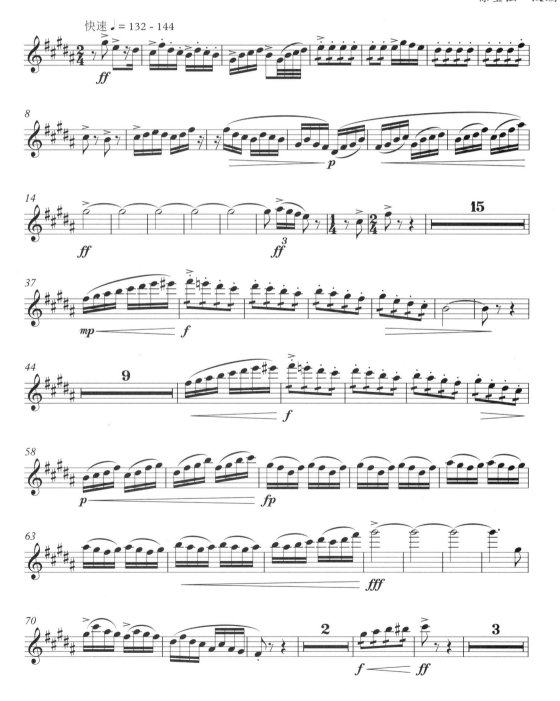

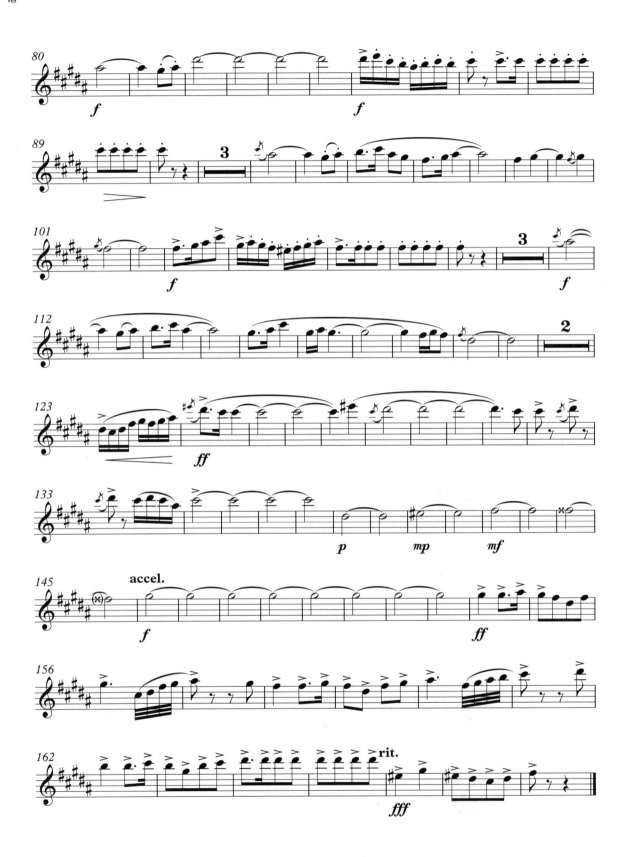

打虎上山
(Alto Saxophone)

选自现代京剧《智取威虎山》
高一鸣 曲
徐坚强 改编

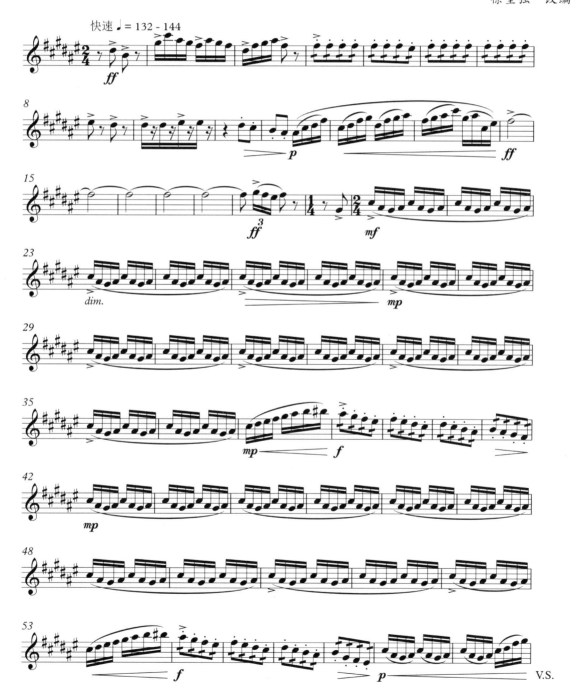

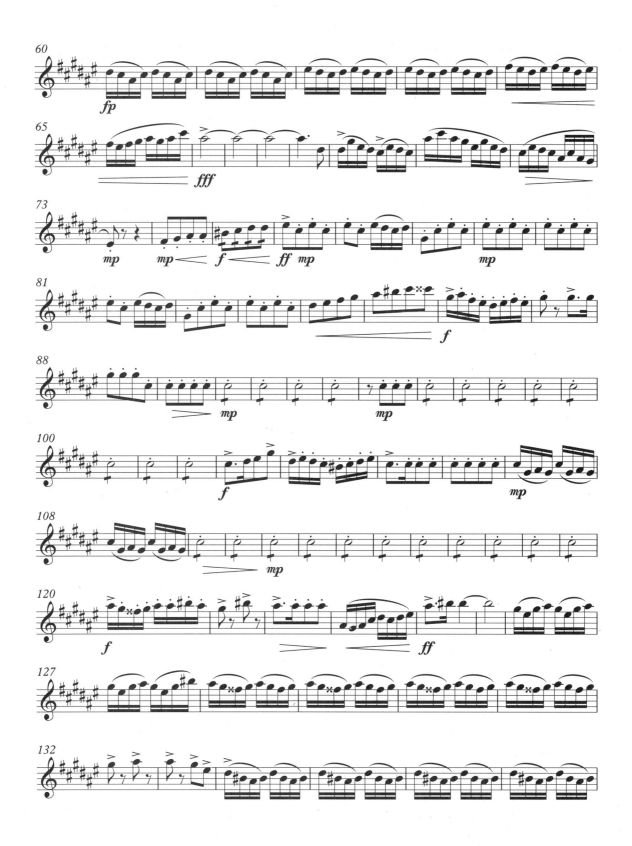

打虎上山（Alto Saxophone）

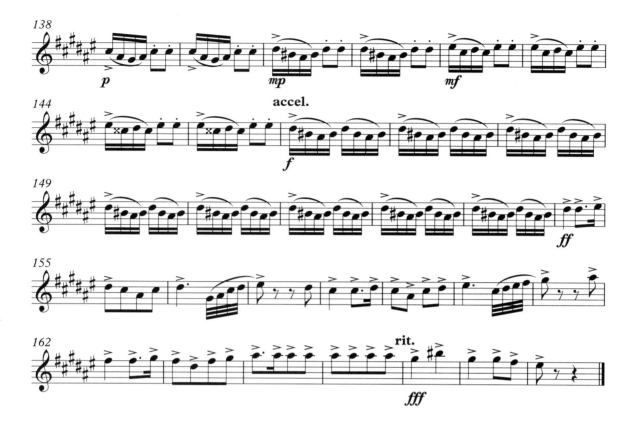

打虎上山

(Tenor Saxophone)

选自现代京剧《智取威虎山》
高一鸣 曲
徐坚强 改编

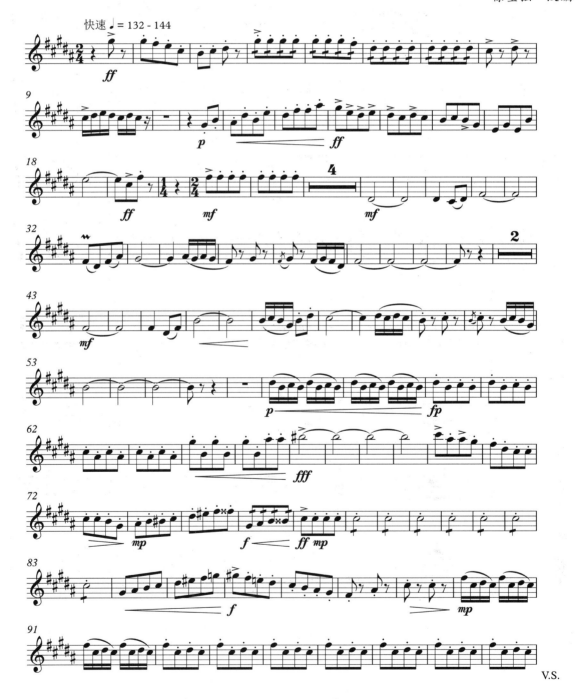

打虎上山 (Tenor Saxophone)

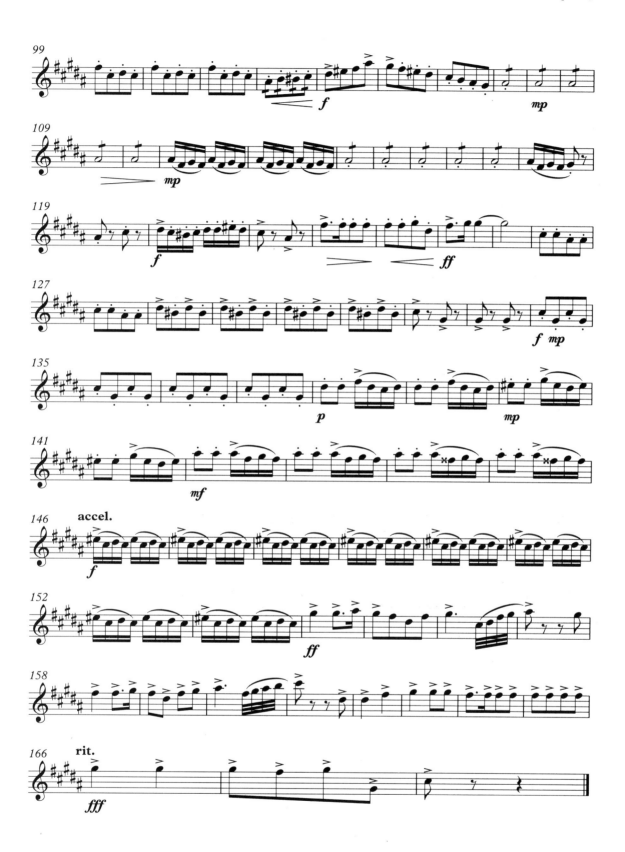

分 谱

打虎上山
(Baritone Saxophone)

选自现代京剧《智取威虎山》
高一鸣 曲
徐坚强 改编

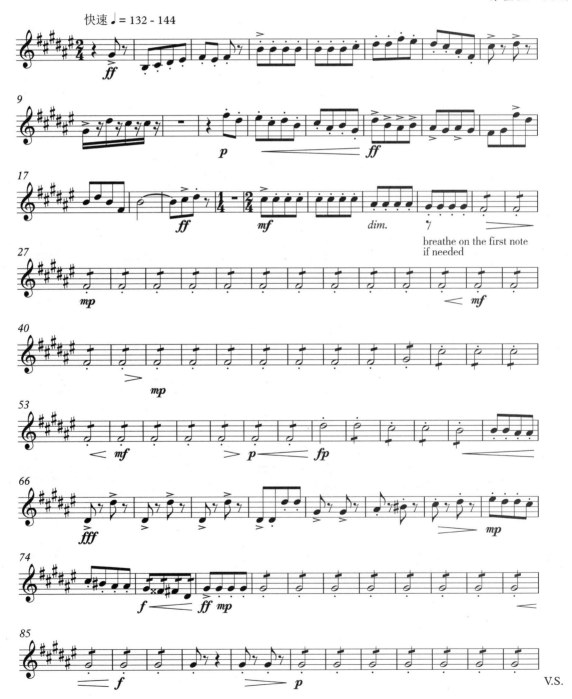

打虎上山（Baritone Saxophone）

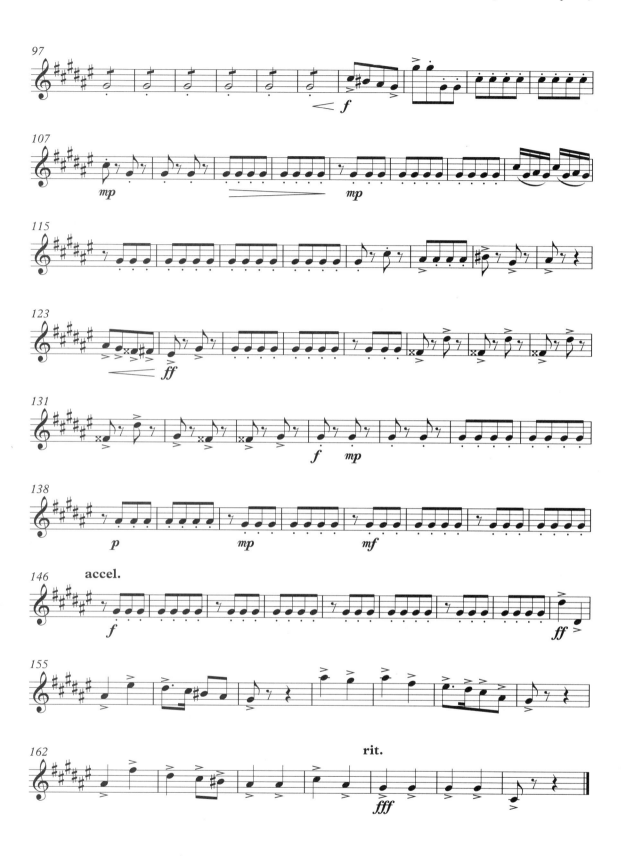

69

归园田居

(Soprano Saxophone)

陶渊明 诗
徐坚强 曲

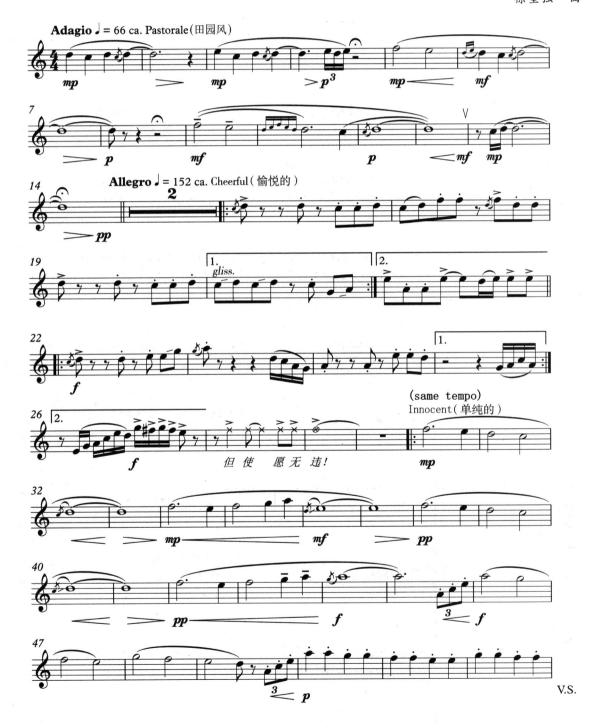

归园田居（Soprano Saxophone）

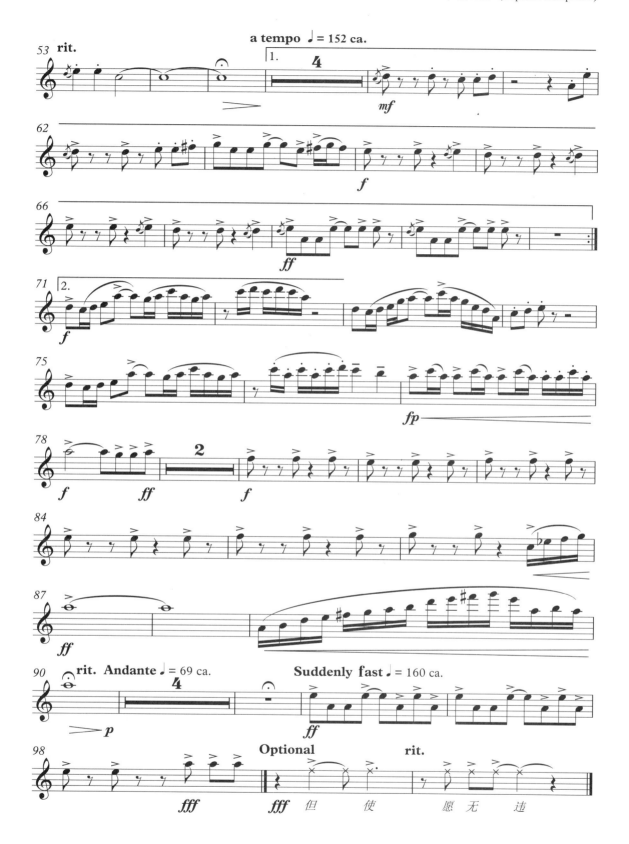

分 谱

归园田居
(Alto Saxophone)

陶渊明 诗
徐坚强 曲

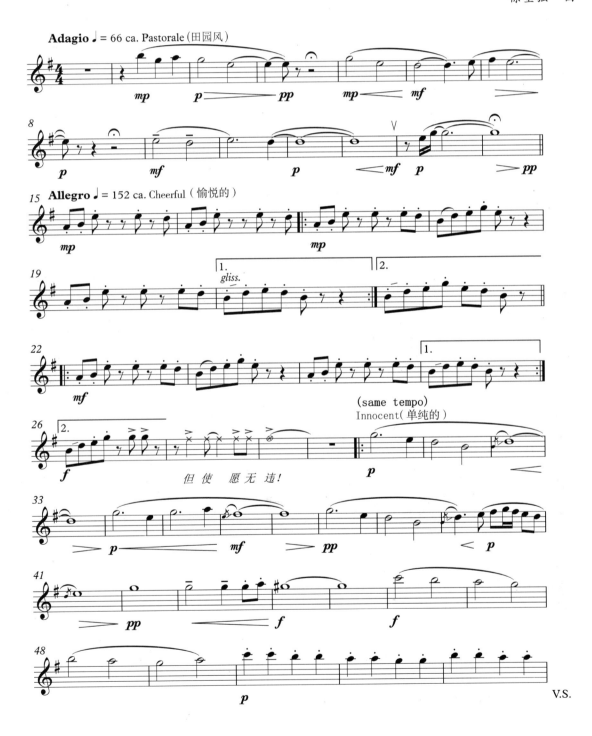

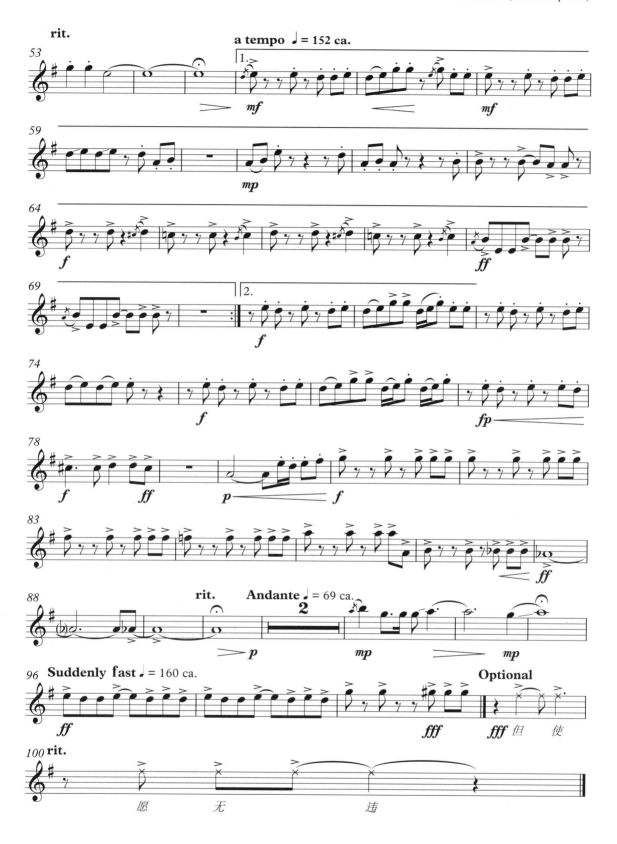
归园田居（Alto Saxophone）

归园田居

(Tenor Saxophone)

陶渊明 诗
徐坚强 曲

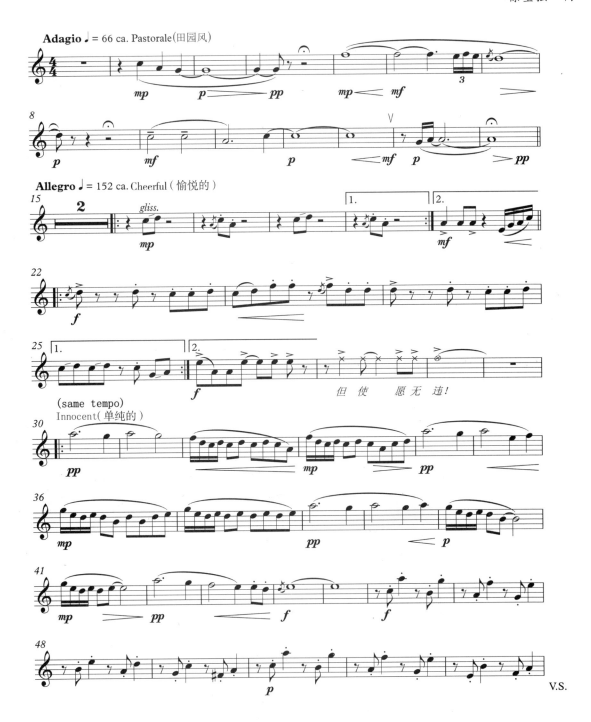

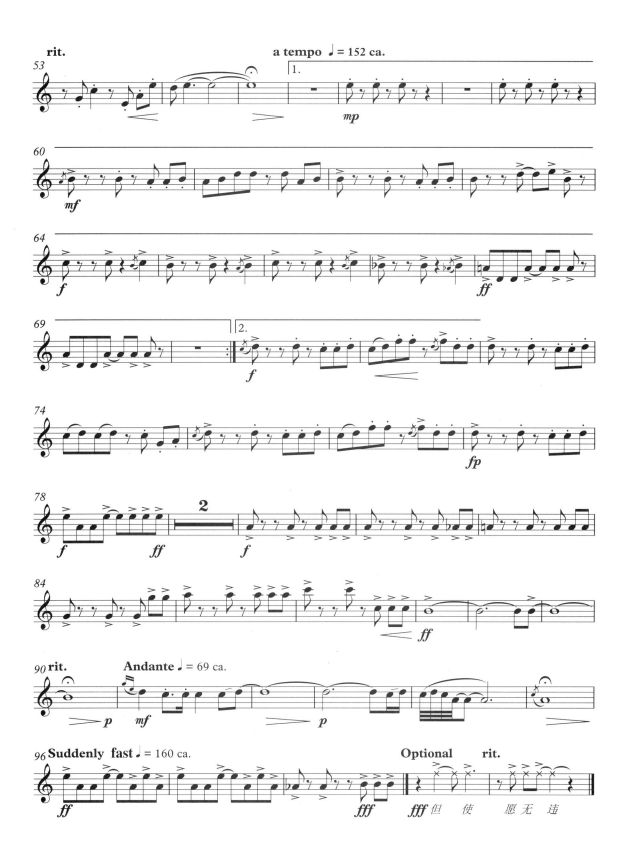

归园田居

(Baritone Saxophone)

陶渊明 诗
徐坚强 曲

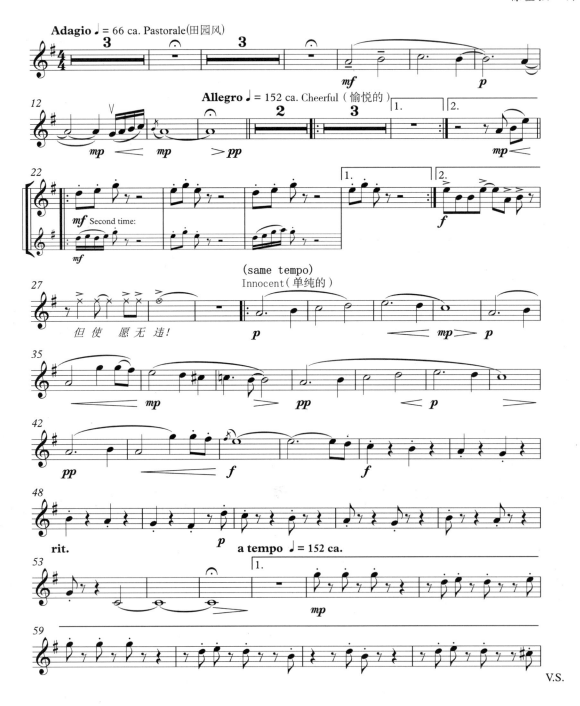

归园田居（Baritone Saxophone）

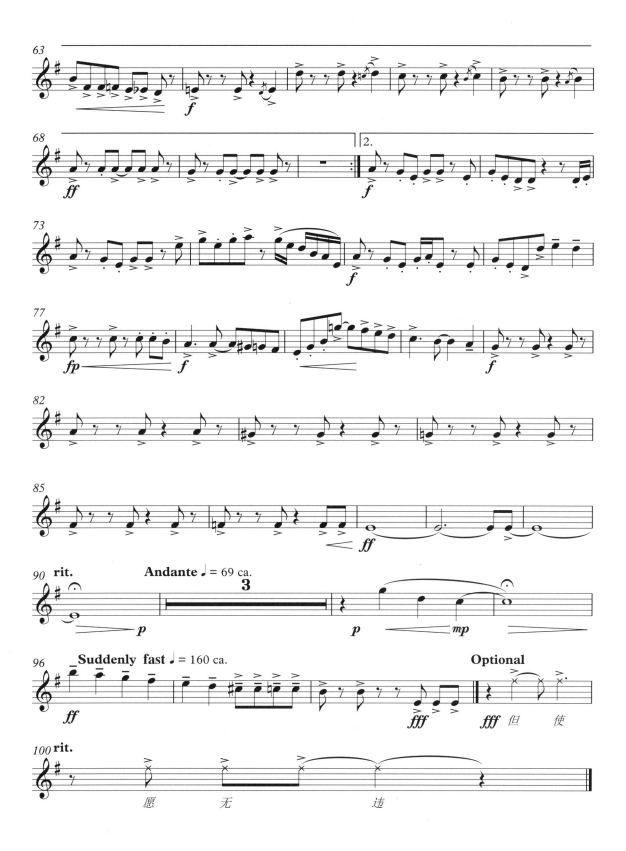

快乐的女战士

(Soprano Saxophone)

选自《红色娘子军》
杜鸣心 吴祖强等 曲
徐坚强 改编

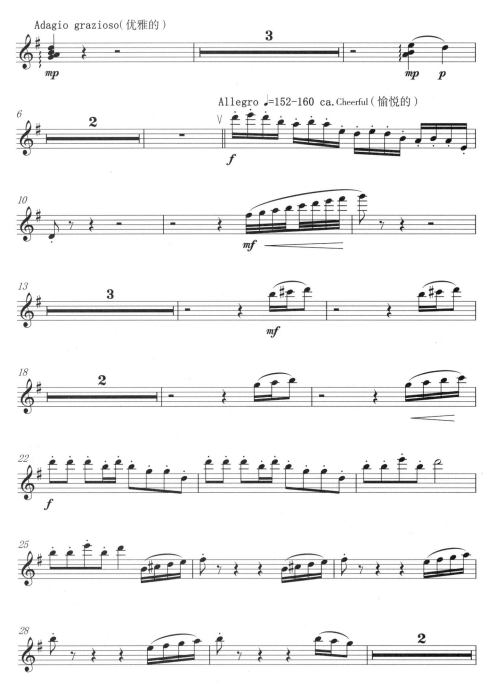

快乐的女战士（Soprano Saxophone）

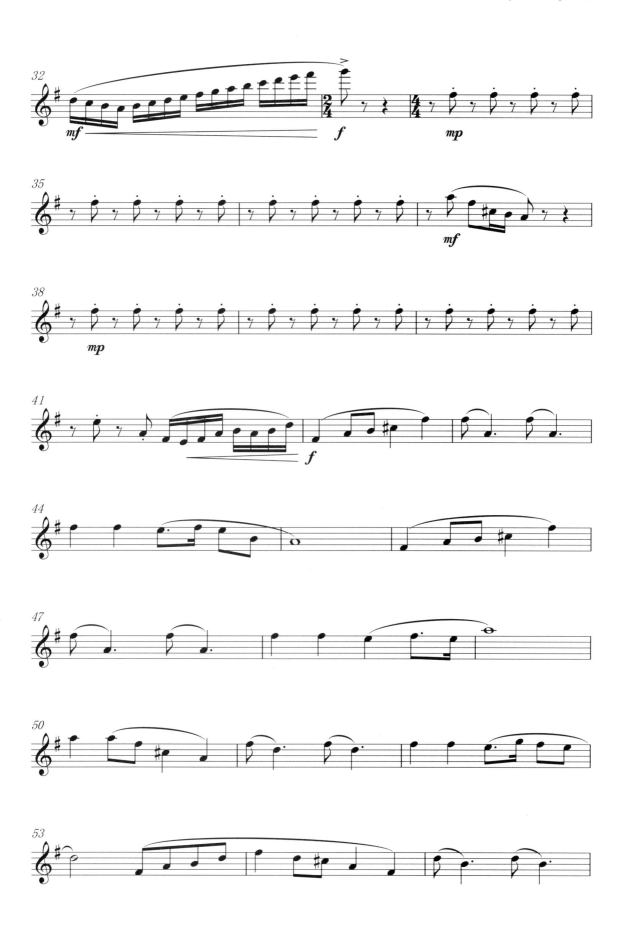

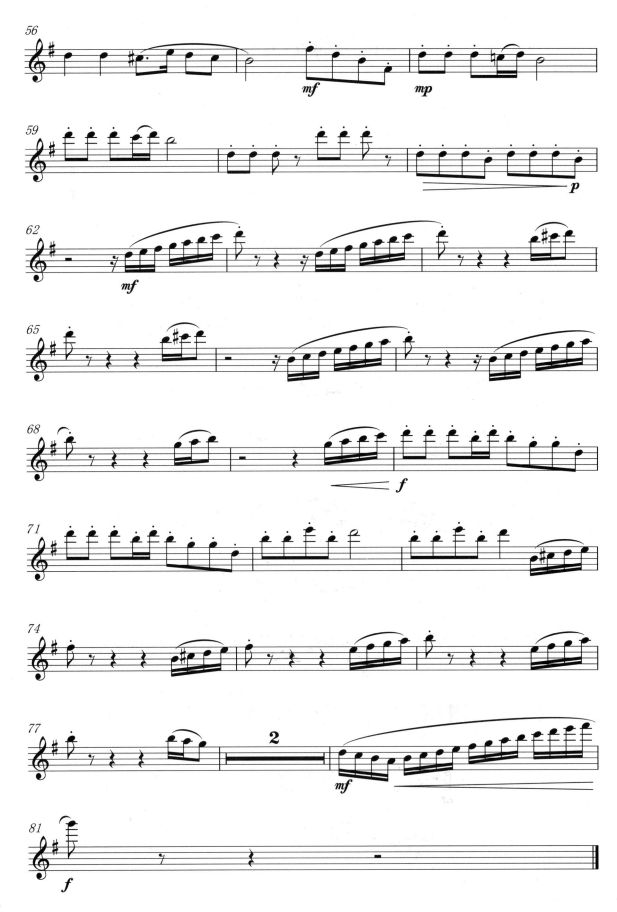

快乐的女战士

(Alto Saxophone)

选自《红色娘子军》
杜鸣心 吴祖强等 曲
徐坚强 改编

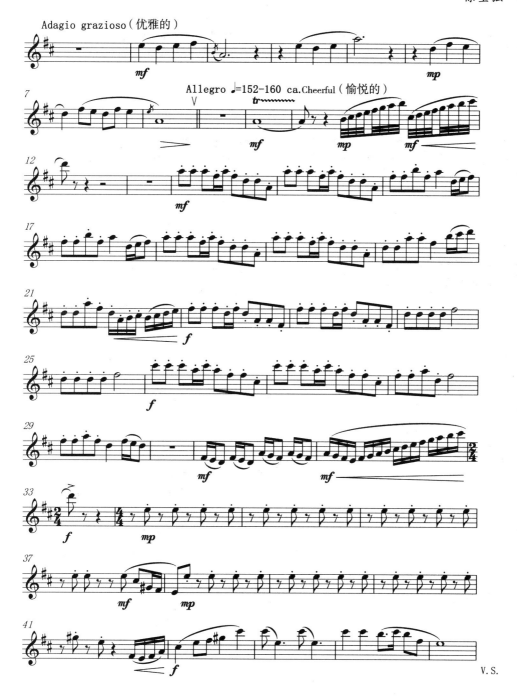

V.S.

81

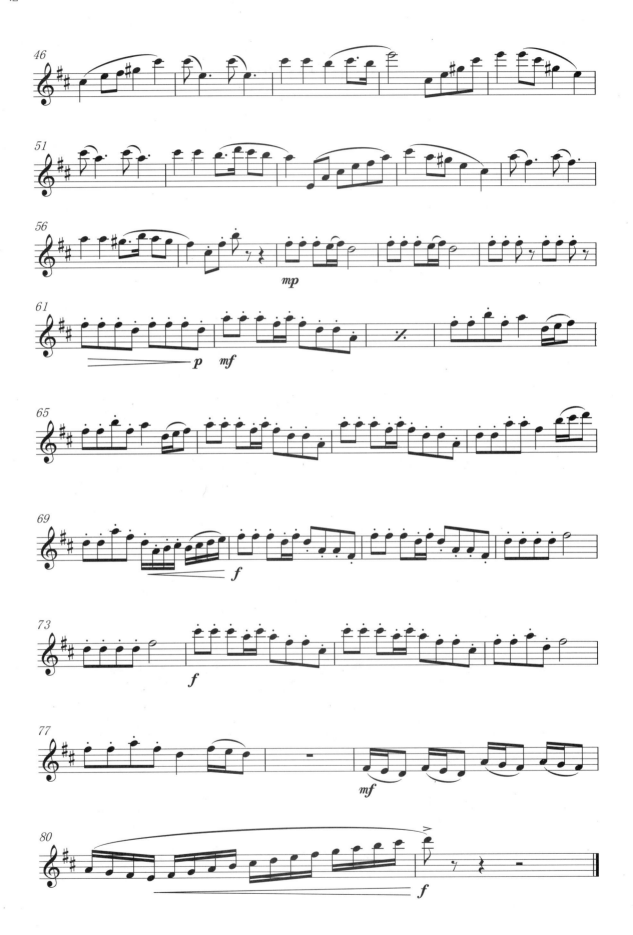

快乐的女战士

(Tenor Saxophone)

选自《红色娘子军》
杜鸣心 吴祖强等 曲
徐坚强 改编

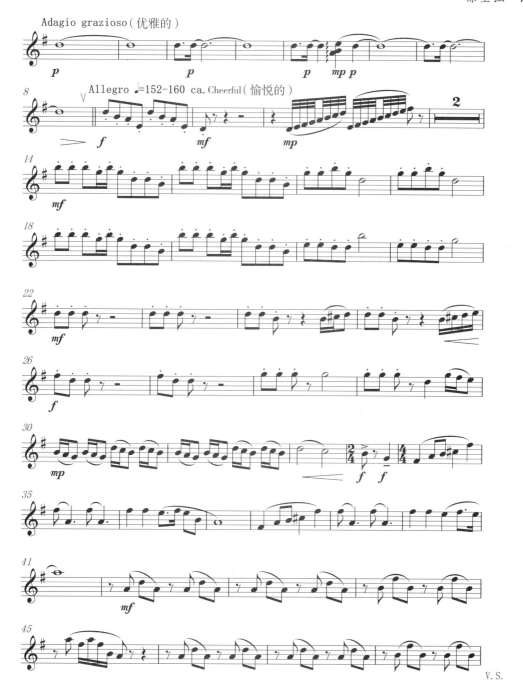

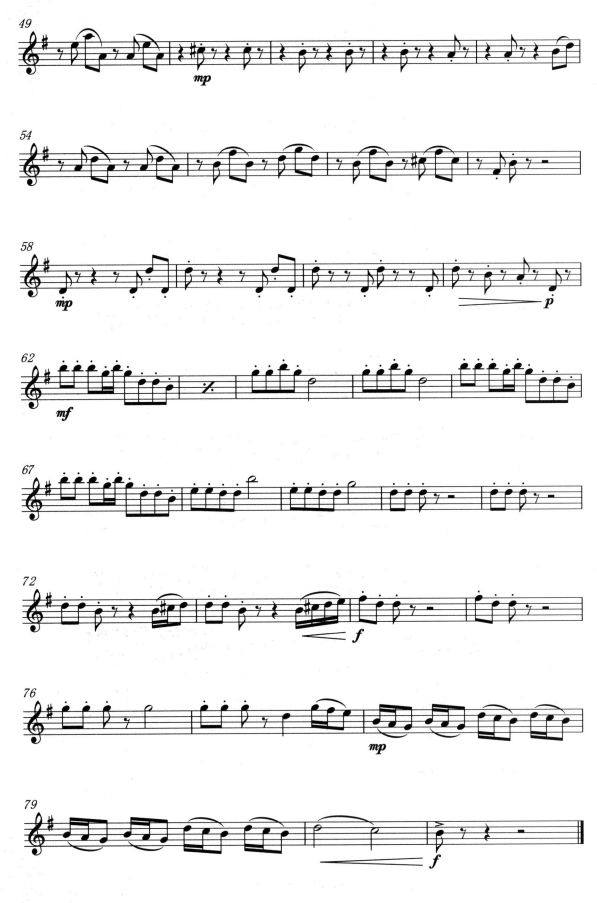

快乐的女战士
(Baritone Saxophone)

选自《红色娘子军》
杜鸣心 吴祖强等 曲
徐坚强 改编

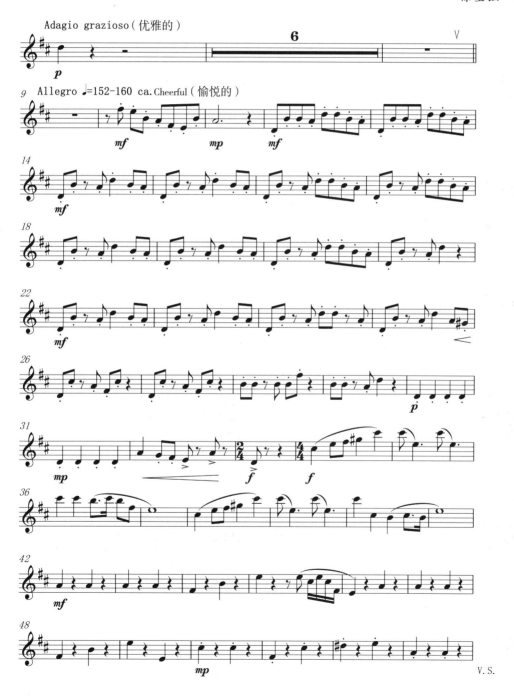

分 谱

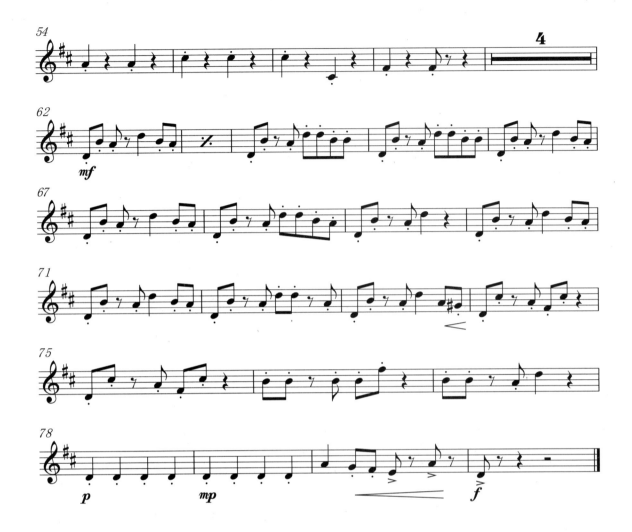

86